IMAGES
of America

TRANSYLVANIA
COUNTY

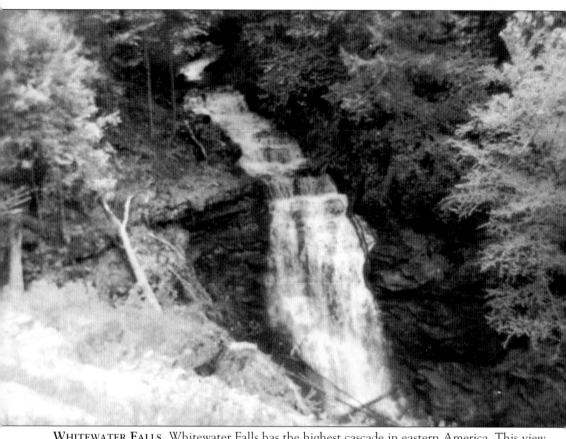

WHITEWATER FALLS. Whitewater Falls has the highest cascade in eastern America. This view was taken in the 1940s. (Photo courtesy of Jo Ann Alderman.)

IMAGES
of America

TRANSYLVANIA
COUNTY

Yvonne McCall-Dickson

ARCADIA

Published by Arcadia Publishing
Charleston SC, Chicago IL, Portsmouth NH, San Francisco CA

Printed in Great Britain

Library of Congress Catalog Card Number: 2004117438

For all general information contact Arcadia Publishing at:
Telephone 843-853-2070
Fax 843-853-0044
E-mail sales@arcadiapublishing.com
For customer service and orders:
Toll-Free 1-888-313-2665

Visit us on the internet at http://www.arcadiapublishing.com

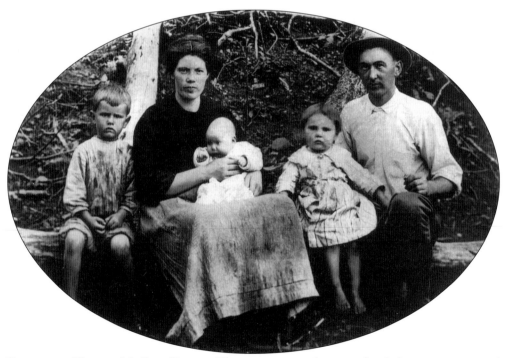

ENNER AND HENSON MCCALL FAMILY. This picture was taken on a family hunting trip around 1918. (Photo courtesy of Cecil Leslie.)

CONTENTS

ACKNOWLEDGMENTS

A project of this size is never accomplished by one person. I would like to personally thank all of the people who have been so supportive and helpful: Jo Ann Alderman, Gwen Ashe, William Austin family, Rena' Bateman, Jo Ann Bryson, Phyllis Cash, Ruby Conner, Rick Cook, Betty Davis, Ellen Davis, Mary Galyon, Jean Gray, Jackie Gunter, William Hemphill, Elvin Holden, Sandy Hoxit, Doyce Jeter, Gary King, Cecil Leslie, Linda McCall, Toni McCall, Kathleen Moore, Mark and Susan Ogle, Jan Osborne, Rev. Ben F. Ormand, Hershel Owen, Kaye McCall Owenby, Kathy Owens, Jean Pace, Evelyn Passmore, Anna Robinson, Sue Sharpe, Stephen Lee Sitton, Betty Sherrill, Sean Trapp, Kathy Visco, John and Lelia von Stein, and the Joseph S. Wilde family.

Finally, I would like to thank my editor, Adam Latham at Arcadia Publishing, my entire McCall clan, and—last but certainly not least—my husband, Wesley Dickson, who is ever my best friend and was there for me during this entire adventure.

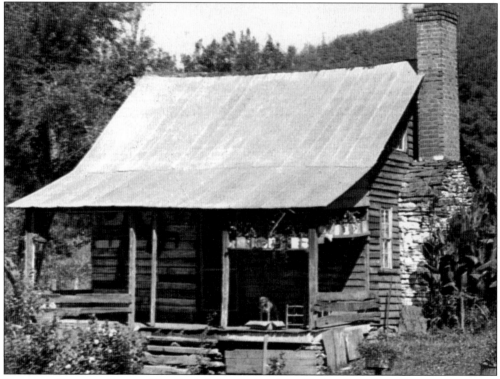

CHARLIE ENGLISH CABIN. The English family lived on Turkey Pen Gap. (Photo courtesy of Sandy Hoxit.)

This book is dedicated with all my love and respect to my mother, Mamie B. McCall.

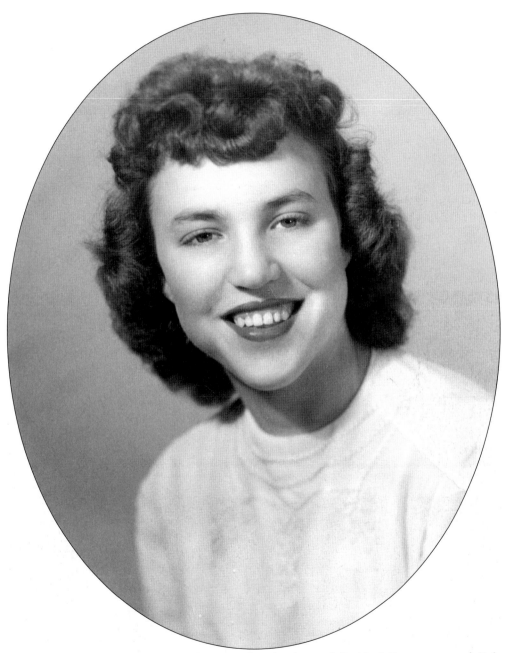

MAMIE BUMGARNER MCCALL. Mamie is the daughter of Radford Bumgarner and Zula Lusk. She is a retired nurse from Transylvania Community Hospital. (Photo courtesy of Mamie McCall.)

Transylvania Pioneer Families

Alexander
Allison
Ashworth
Bagwell
Banther
Barton
Bracken
Breedlove
Bridges
Brooks
Brown
Bryant
Cagle
Case
Clayton
Davidson
Deaver
Dunn
England
English
Fisher

Galloway
Garren
Gillespie
Glazener
Gravley
Hamilton
Hamlin
Heath
Henderson
Hogsed/Hoxit
Jones
Jordan
Justice
Killian
Kilpatrick
King
Kuykendall
Landreth
Lankford
Lance
Lyda

Lyon
McCall
McCrary
McGaha
McMinn
Merrill
Mills
Morgan
Morris
Murr
Neill
North
Orr
Osborne
Osteen
Owen/Owens
Parker
Patton
Pickelsimer
Poor
Raxter

Reid
Robinson
Scruggs
Shipman
Sims
Siniard
Sanders
Smith
Stepp
Stroup
Tinsley
Waters
White
Whitmire
Wilson
Winchester
Wood
Young

THE HEADWATERS OF DAVIDSON RIVER. When the Samuel McCall family came to Transylvania County in 1803, they settled along the headwaters of the Davidson River. (Photo courtesy of Wesley Dickson)

One
RIDING THE STORM OUT

And the only tune that the fiddle would play is, oh, the wind and the rain. . . .
—"Wind and Rain," Traditional

In 1861, a group of settlers wearied of long journeys for business established a new county called Transylvania. As the justices of the peace met for the first time to discuss building a courthouse, electing a sheriff, and appointing a board of education, North Carolina seceded. In Western North Carolina, many citizens felt a break from the Union would not be to their benefit. Before Fort Sumter, Western North Carolina had been in negotiation with Eastern Tennessee about forming a new state, a move in which West Virginia was the precedent. After Fort Sumter however, the war was on. Tennessee seceded right after North Carolina and was the last state to do so.

Transylvania County's first duty was now to recruit a company of soldiers to send to the Confederate troops. Capt. Francis W. Johnstone commanded the first volunteers, Company E of the 25th Regiment. Transylvania would send two more companies into Lee's service: Companies E and K of the 62nd were organized in July 1862 with 11 non-commission officers and 137 privates. The forges at Davidson River Iron Works refired. Transylvania County, North Carolina, and the South would never be the same.

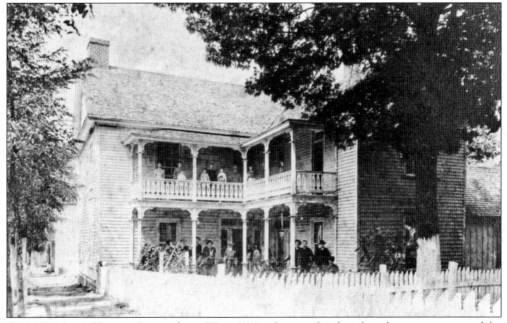

THE McMINN HOUSE. Located on West Main Street, this hotel and store was owned by Nathan van Buren McMinn and was one of the first places of business in Brevard. Nathan married Lizzie England, whose father Alexander donated the land for Brevard along with Leander Gash and B.C. Lankford. (Photo courtesy of the Historic Preservation Commission.)

JOHN A. MCCALL. Six of John's seven sons served with 62nd North Carolina Infantry Regiment, Company K: William, John Jr., Andrew Jackson, Jehue, Tyra, and Handsell. His youngest, Jason Coleman, was too young to serve. Three of John's sons-in-law also served in Company K: James Marion Owen, husband of Hettie; Andrew Jackson Owen, husband of Mary Ann; and Robert Monroe Galloway, husband of Susan Jane. Monroe's sisters Evelina, Sarah, and Selena were married to Handsell, Tyra, and Andrew Jackson McCall, respectively. (Photo courtesy of Mildred Shular Lee.)

CPL. ANDREW JACKSON OWEN. In his report of Cumberland Gap, Lt. Col. B.G. McDowell wrote: "A braver or more courageous body of men did not belong to the Confederate army. They left their homes . . . and offered their lives a sacrifice upon the field of battle . . . this regiment when it went into camp for drill, was without arms, except a few old muskets were furnished them for drilling purposes . . . men never behaved with more coolness and courage than did the men of the Sixty-second Regiment." (Photo courtesy of Ronville Owen.)

LEONARD CAGLE GRISTMILL. This Davidson River gristmill was located on the river opposite the present Sycamore Flats Picnic Area. Leonard Cagle (1798–1866) was listed on the Volunteers Muster Roll of Transylvania County in 1861. Leonard and wife Mary Osborne (1797–1869) had three sons and six daughters. Two sons served in the Confederacy, and one joined the Union Army. Leonard moved his family to Cedar Mountain, and during the Civil War Martin Simpson of Clotho operated the mill for him. (Photo courtesy of Mary Galyon.)

JAMES HENRY CAGLE. Leonard's son, James Henry Cagle, was a recruiter for the 3rd North Carolina Mounted Infantry, Company D, Union Forces during the fall of 1864. While taking his recruits to headquarters in Greenville, Tennessee, he encountered a Confederate conscription at Crab Creek. During the skirmish, all the Confederates were slightly wounded, and one was killed. Cagle was shot in the right hip and left breast. John B. Wood, of Wolf Mountain, and A.L. Galloway, carried him to the home of Martin Simpson. Simpson cleaned Cagle's wounds, and they hid him near a rocky cliff until he was able to travel. (Photo courtesy of Sandy Hoxit.)

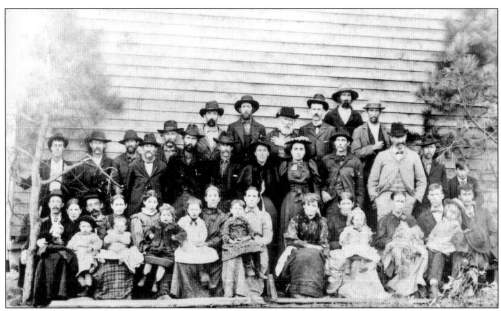

THE JOHN DICK OWEN FAMILY. Lt. John Dick Owen served in the Confederate Infantry. On a cold night, as he made his way home for a few days' leave, he found a small black boy around four years old half frozen and sick. Dick carried the child home to his wife, who nursed the boy back to health. Soldiers had picked up the boy—named Pete—near his home in lower South Carolina or Georgia. Pete lived with the Owens as a member of the family for over 20 years. (Photo courtesy of the Historic Preservation Commission.)

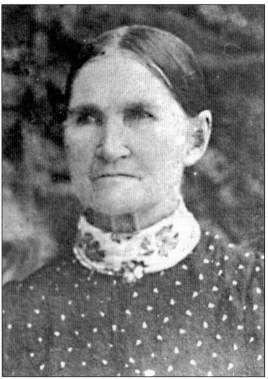

MARY ANN MCCALL OWEN. Mary Ann, the wife of Andrew Jackson Owen, represents the many women left alone during the war to care for their families and work the farm. Many women toiled in the fields to grow food for their children. Many families were at the point of starvation and motivated deserters to flee the war in order to save loved ones. Compounding their worries was the constant fear that husbands, fathers, and brothers would never return. (Photo courtesy of Linda McCall.)

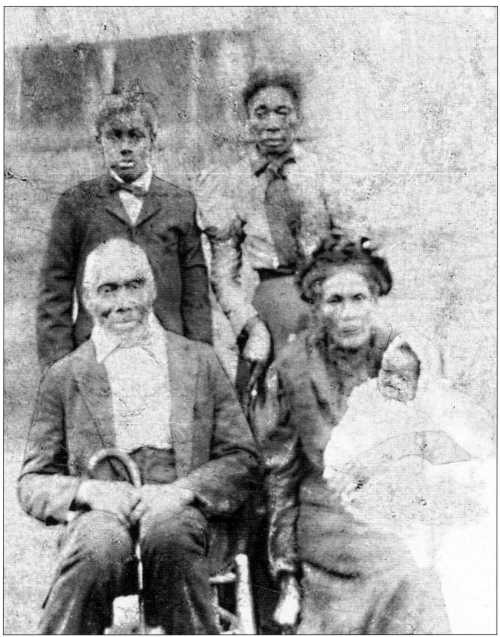

SAM AND MIRA STEWARD. Sam and Mira Steward were both born into slavery but died as free Americans. A plantation economy never developed in Transylvania County, and few families engaged in slave labor. Those that did employed them as farm hands or in stores and inns. After the war, African-American men and women obtained land of their own and worked in farming, mining, or logging. (Photo courtesy of Doyce Jeter.)

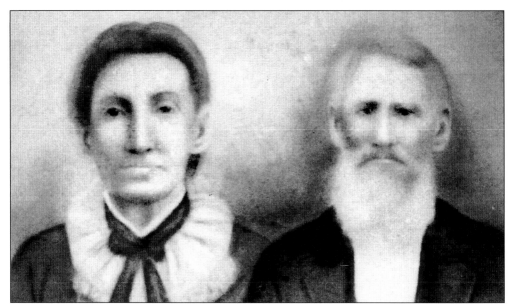

Anna Jane Nicholson and William Coffey Dunn. Rev. William Coffey Dunn fought in Company K of the 62nd North Carolina Infantry Regiment. A large number of Company K were captured at Cumberland Gap and imprisoned for 23 months at Camp Douglas, where many died of disease and vermin. Support for the Confederate cause diminished as the war grew old. Taxes and conscription laws tried the loyalty of weary citizens, who prayed for the war's end. (Photo courtesy of Hershel Owen.)

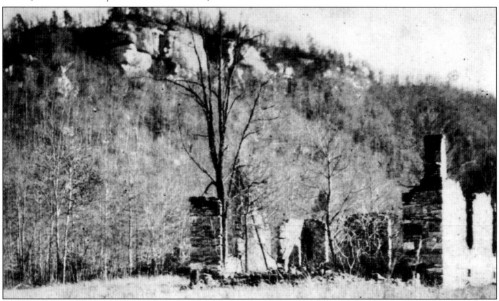

Hume Hotel at Dunn's Rock. In the fall of 1863, Eastern Tennessee fell to the Union. Confederate deserters as well as Union prisoners fled to the mountains for refuge. Men from the area who had remained loyal to the Union crossed the border into Tennessee to enlist. Open violence erupted as vigilante groups raided communities under the flag of patriotism. Unspeakable acts followed and left their mark for generations to come. The Hume Hotel was a casualty of war. (Photo courtesy of the Historic Preservation Commission.)

Two
REFORGING THE PLOW

Many days you have lingered around my cabin door, oh, hard times come again no more.
—Stephen C. Foster

Prior to the Civil War, individual farming was the primary occupation of Transylvania County residents. Next came the gristmills and sawmills, stores, and a few other businesses such as Matthew Gillispie's gun works out on East Fork or Jimmie Neill's hattery, in what is now the Pisgah Forest community. At the war's conclusion, weary soldiers made their way back home, only to find their farms in want and neglect. Starting from scratch, these resilient men and women began reconstructing their lives. Faith in God became stronger than ever as the community worked together to heal their wounds. Industry slowly but surely began to creep in; mining iron, mica, and kaolin became a way of making money. Women and children gathered herbs and roots to sell. Life began to take on a sense of normalcy again, and community activities were resumed.

Many families continued to work in handicrafts. The tradition of handicrafts had nearly died out after the war, as factory-made goods became widely available. The 1876 Centennial provided a catalyst as interest renewed in colonial artifacts. Weaving and handmade furniture experienced a popular resurgence. The added income improved the standard of living for many.

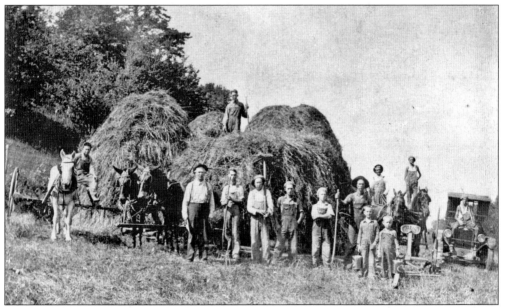

CATHEY'S CREEK FARM. Pictured are Leroy Waldrop on mule and Mays Waldrop on the hay wagon; in front on the wagon are Tom Galloway, Reuben Bracken, Pete Lance, Lewis Waldrop, Jim Waldrop, and Mannie Waldrop; the water boys are Hovey and Arthur Waldrop; standing on the wagon are Van Buren Waldrop and son Ray Waldrop; Robert B. Waldrop is on the truck hood. (Photo courtesy of Jean and Leon Pace.)

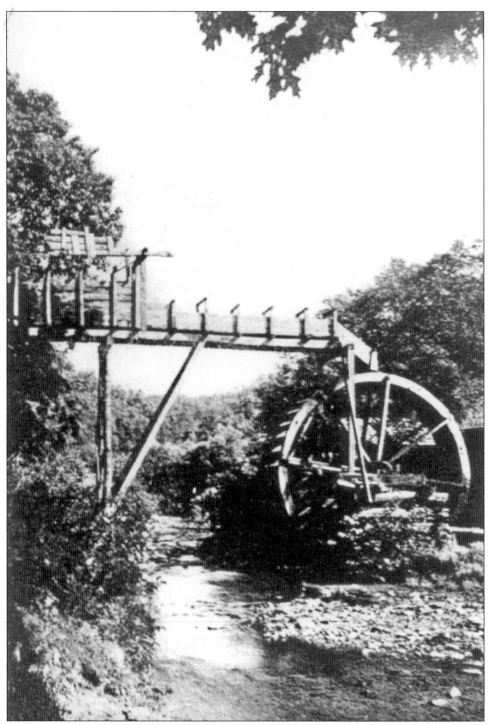

BREESE MILL. Powered by King's Creek and located at the intersection of Caldwell and Whitmire Streets, this mill ground flour and cornmeal until it was destroyed in the 1916 flood. Three years later, Big Jim Morgan bought the 30-foot wheel for use at Morgan's Mill, located in Cherryfield. (Photo courtesy of the Historic Preservation Commission.)

McCall Gristmill. William M. "Bill" McCall made his living from this gristmill, located at Bird Rock Falls in Balsam Grove. Gristmills (there were around 20 in Transylvania County) were a backbone of any community, as all needed their corn, wheat, and rye ground. (Photo courtesy of Toni McCall.)

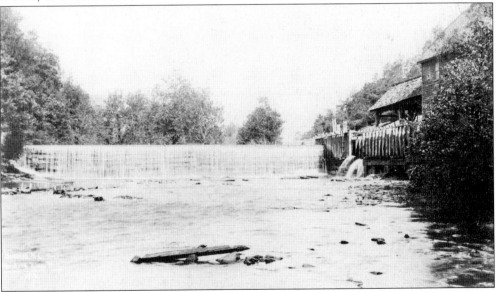

Davidson River Milling Company. This Linsey-Woolsey mill manufactured clothing fabric. Before the Civil War, weaving looms were more common. Most weaving was done by women filling their household needs. Flax, wool, and cotton were used for spinning and weaving. The earliest looms had two shafts which could produce only plain woven cloth. As manufactured cloth became available, many of these looms were converted to four shafts, allowing the weaving of decorative items such as coverlets. By the 1890s weaving was considered a "lost art." (Photo courtesy of the Historic Preservation Commission.)

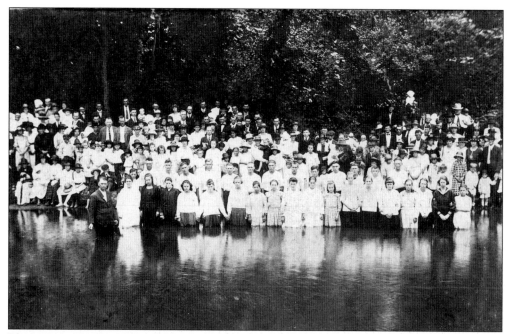

BAPTISM BY IMMERSION. "And Jesus, when he was baptized, went up straightway out of the water: and, lo, the heavens were opened unto him, and he saw the Spirit of God descending like a dove, and lighting upon him." Matthew 3:16. (Photo courtesy of Mary Galyon.)

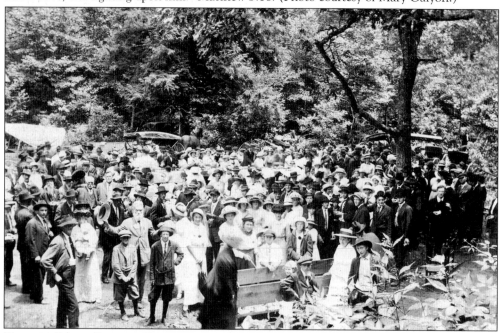

TURKEY CREEK BAPTIST CHURCH. Organized August 6, 1895, with charter members S.V. Brown, Lena Newton, J.A. Brown, and Mr. and Mrs. J.R. Alexander, the church was also used as a school. This photograph was taken at Homecoming in 1915. While all the people in this gathering cannot be identified, the Morris family is in front, and the fellow waving his hat is Jasper Orr. In 2004, the area was Mine Mountain Estates. (Photo courtesy of Mary Galyon.)

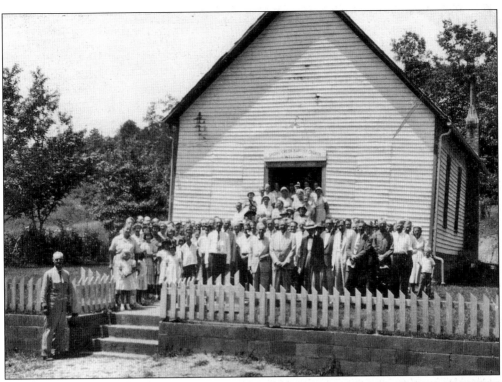

SHOAL CREEK BAPTIST CHURCH.
Churches and schools took priority
once more and began to fill as a sense
of structure returned. Churches
provided a social environment as well
as a religious one, and folks looked
forward to seeing each other and
worshiping together. The first pastor of
Shoal Creek was Rev. William Coffey
Dunn, who was born and raised in
Cathey's Creek. (Photo courtesy of
Keitha Fay McCall Reid.)

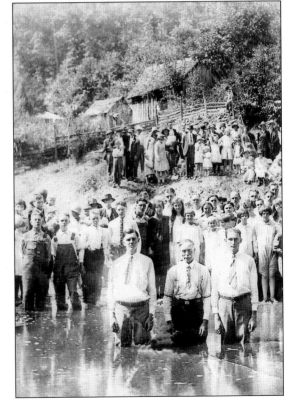

MCCALL BAPTISM. Baptism is a way of
declaring to the world that a person has
accepted Christ and been "born again."
It is done by immersion to symbolize
death to sin and rebirth in Christ.
(Photo courtesy of Rena Bateman.)

19

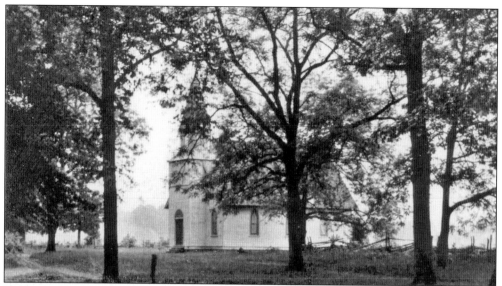

DAVIDSON RIVER CHURCH. This church, established in the 1820s, housed the Davidson River Academy. Prior to worship in the church, a camp meeting was held in the grove of walnut trees. Davidson River itself was named for Benjamin Davidson, who was born May 20, 1787, and was known as "Independent Ben" as his birth date fell on the anniversary of the Mecklenburg Declaration of Independence. First known as "Ben Davidson's Creek," the river was later named Davidson River. A rock from Ben Davidson's house is laid in the foundation of the present Brevard-Davidson River Presbyterian Church. (Photo courtesy of the Historic Preservation Commission.)

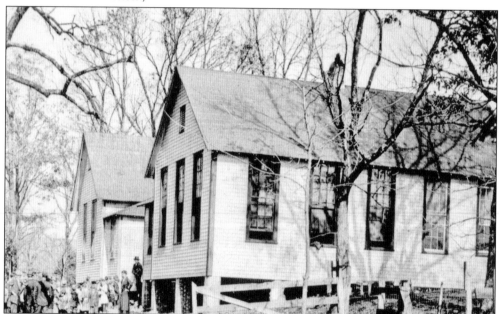

DAVIDSON RIVER ACADEMY. The second Davidson River Church building was erected around 1855 with two large schoolrooms. Pupils paid tuition to study reading, writing, and algebra. The church itself was destroyed by fire in 1891 and was replaced with a third building, which stood until 1975. (Photo courtesy of Mary Galyon.)

20

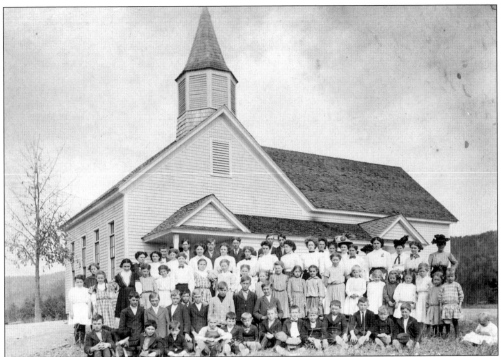

DISTRICT NO. 3 LITTLE RIVER. Most schools were a natural growth of the church and shared the same building. In 1908, a new one-room school was constructed on the hill above the Little River Church. A second room was added two years later, when enrollment reached 68. Eventually, a third room followed. The Penrose School was established when the Little River School merged with the Enon School. (Photo courtesy of the Historic Preservation Commission.)

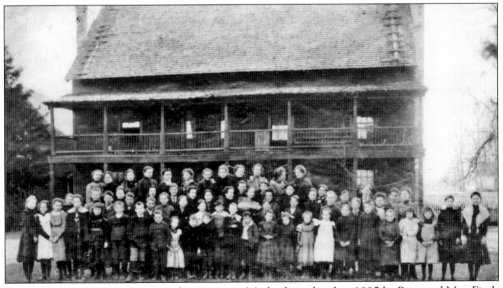

EPWORTH INSTITUTE. Originated as a private Methodist school in 1895 by Rev. and Mrs. Fitch Taylor, the Epworth School eventually evolved into the Brevard Institute and moved to the current location of Brevard College. (Photo courtesy of the Historic Preservation Commission.)

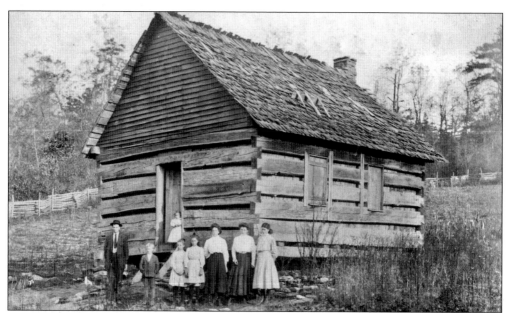

QUEBEC SCHOOL. One of the first teachers at the Quebec School was Alice Justus. The teacher in this photograph is Napoleon Miller. Since school supplies were limited, parents contrived to supply learning aids. The alphabet was burned onto a plank board. Soapstone was used as a writing instrument for slates, since it was abundant in the Gloucester area. Among the schoolchildren pictured above are Mamie and Myrtle Reese, Lula Thomas (Owen), and Leltia Miller (Fisher). (Photo courtesy of the Historic Preservation Commission.)

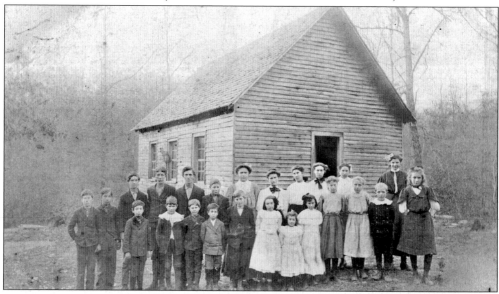

OWEN SCHOOL IN BALSAM GROVE. In 1840, John Owen II donated the land for this schoolhouse, which housed students through the fifth grade. By 1844, it was so overcrowded that the newly formed Macedonia Church housed a subscription school for a full year. Owen School was later consolidated with Pine Grove to become Silversteen School. Jim Anders and his sons, Herbert and Bill, constructed a new building in the 1920s with lumber donated by Joseph Silversteen. (Photo courtesy of the Historic Preservation Commission.)

T.C. HENDERSON. Until the turn of the century, the board of education had not been very active in providing a better environment for learning. That changed when Thomas Calhoun Henderson became the superintendent of schools. He served from 1905 to 1917 and again from 1923 to 1929. He was instrumental in providing an eight-month term for all grades and races. He established public transportation for school children. (Photo courtesy of Linda McCall.)

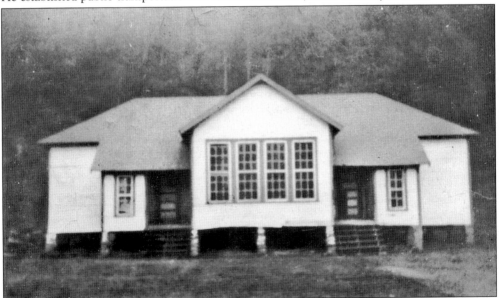

BALSAM GROVE SCHOOL HOUSE. A frame building with adequate seating and lots of windows for light was the realization of T.C. Henderson's dream. Under his leadership, Transylvania County built and furnished two new high schools—Brevard and Rosman—and ten elementary schools—Balsam Grove, Brevard, Cedar Mountain, Connestee, Enon, Lake Toxaway, Quebec, Rosman, Rosenwald, and Silversteen. (Photo courtesy of Linda McCall.)

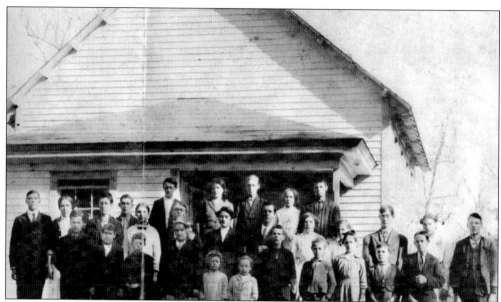

SCHOOLHOUSE ONE. Around the turn of the century, a one-room building was heated with a wood or coal-burning stove in the center. Light was provided by lanterns. The grades usually ranged from first to eighth and were all taught in 10–15 minute sessions by one teacher. Students packed their lunches from home and helped with the daily chores, which included sweeping, dusting, fetching fuel and water, and dusting erasers for the blackboard. This school may be Montvale. (Photo courtesy of Phyllis Cash.)

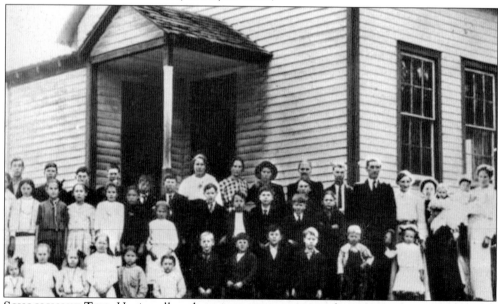

SCHOOLHOUSE TWO. Having all students in one room was an advantage to the younger grades, because they could be taught by the older children and could listen to their lessons. The room was divided according to grade and often by gender. Typically, boys sat on one side of the room and girls on the other. They also had separate cloakrooms. On February 25, 1911, the North Carolina General Assembly ratified an act for compulsory attendance of school in Transylvania County. This school may be Pine Grove. (Photo courtesy of Phyllis Cash.)

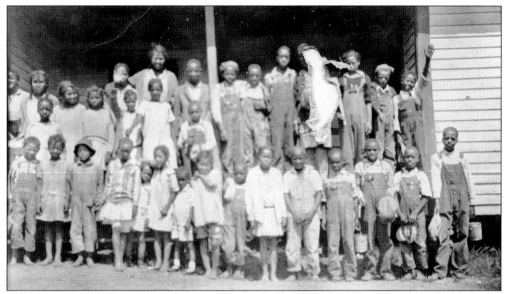

GLADE CREEK SCHOOL. The first school in Glade Creek was conducted in the French Broad Church building, which burned in 1866. Other African-American schools included one on Everett Road and Shady Grove. The first African-American public school, on Rice Street, was replaced by the Rosenwald School, built in 1910. This picture was taken at Glade Creek around 1926. The missing child is Genevieve Gash, who cut herself out of the picture because she disliked going to school. (Photo courtesy of Doyce Jeter.)

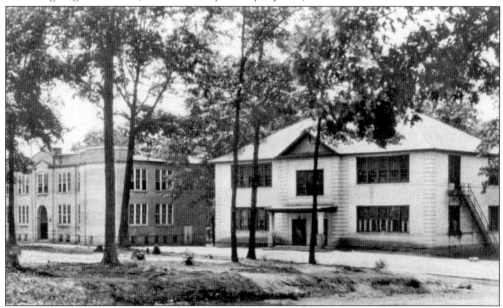

BREVARD HIGH SCHOOL. The frame building on the right was built in 1908 on the corner of Morgan Street and Broad. Prior to its construction, public school had been unavailable in the town for over two years. As the number of students steadily increased, the need for another building was felt. In 1919, the brick building to the left opened as Brevard High School, while the old building continued as the grade school. (Photo courtesy of the Historic Preservation Commission.)

CAMP CHERRYFIELD. Transylvania County has an ideal environment for summer camps. In the 1920s, the county boasted a record high of 14 camps. Camp Cherryfield for girls was located near Rosman. It was built around 1926 and operated by Alex Kizer. The Depression forced the closing of the camp, which was used as a club during the 1950s. In 1963, Monty and Julia Oates bought the camp, and it is now Camp Kahdalea for girls. (Photo courtesy of the Historic Preservation Commission.)

CAMP CHICKASAW. Camp Chickasaw was located on the J. Adger Smythe farm on Deerwood Lane. Built in 1926 by George Morris and J.H. Townsed of Memphis, Tennessee, it was originally a camp for boys. After changing hands several times, it became Camp Deerwoode for girls in 1935. In 1962, it reverted back to a camp for boys but kept the name Camp Deerwoode. (Photo courtesy of the Historic Preservation Commission.)

GWEN VALLEY LODGE. Gwen Valley Lodge was located in Dunn's Rock and was originally called Connestee Cove for girls. Rev. and Mrs. Samuel C. Morris established it in 1923. Reverend Morris built the cabins himself. After changing hands once, the camp was purchased in 1942 by Miss Mary Gwen and became Camp Gwen Valley for boys and girls. (Photo courtesy of the Historic Preservation Commission.)

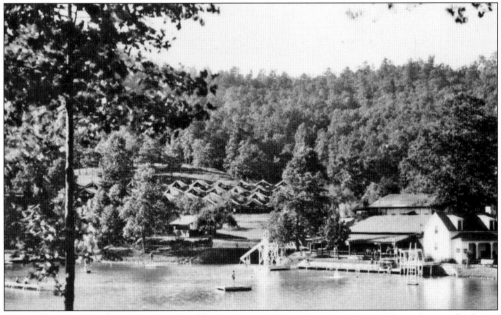

CAMP TRANSYLVANIA. The fourth oldest camp in the county was Camp Transylvania for boys, established in 1920 by Maj. John W. Moore and Fred Miller. Note the tents in the background. Miss Mary Gwen rented the camp from 1936 to 1941 and ran it as a girls' camp. In 1943, Dr. James Christian Pfhol leased the camp and ran it as a music camp. In 2004, it was the Brevard Music Center. (Photo courtesy of the Historic Preservation Commission.)

CAMP TOXAWAY. Camp Toxaway for girls was established in 1922. Located on the headwaters of Toxaway River, it was built as a hunting lodge by a Brazilian rubber planter and called Cold Mountain Lodge. The lodge boasted guests such as Edison, Carnegie, and H.D. Rockefeller. The camp shut down during the Depression and never reopened. (Photo courtesy of Jo Ann Alderman.)

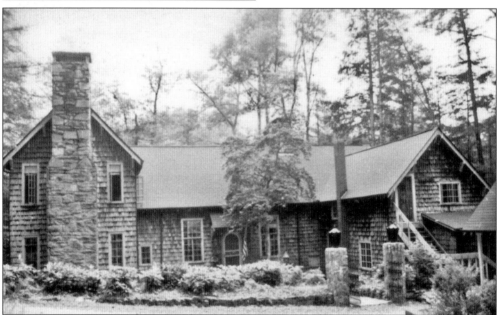

CEDAR MOUNTAIN LODGE. Attracted by the area's rivers and forests, wealthy sportsmen traveled to the mountains for recreation, leisure, and enjoyment. They usually came in groups and spent their days hunting, fishing, hiking, or boating. A lodge was the ideal place to gather at the end of the day, where they would enjoy a good meal and swap stories over brandy and a cigar. (Photo courtesy of the Historic Preservation Commission.)

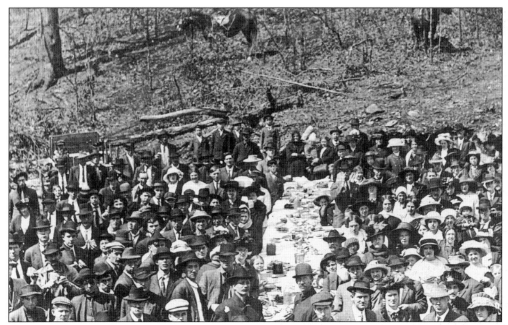

TRANSYLVANIA SINGING. Music has always been as natural as breathing to the mountain community. Ballads, folksongs, and dance tunes lingered from the pioneers. The fiddle was the main instrument until the mid-19th century, when the banjo entered the scene, with the guitar following later. Religious music evolved to include folk hymns and shape-note music, both of which were popular during the settlement days. Later gospel music experienced an influence by ragtime and popular music. This picture was taken around 1917. (Photo courtesy of Liesa Ann Owens Swejkoski.)

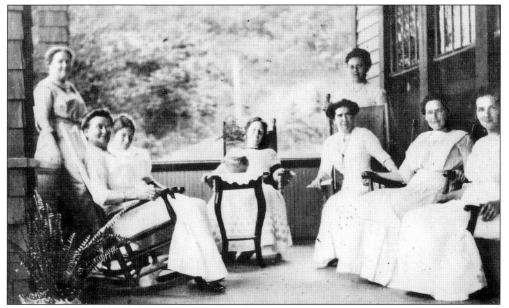

LADIES IN THE AFTERNOON. By the turn of the century, the wounds of the Civil War had begun to heal, and a civilized manner had returned. The war itself was referred to as the "Late Unpleasantness." (Photo courtesy of the Historic Preservation Commission.)

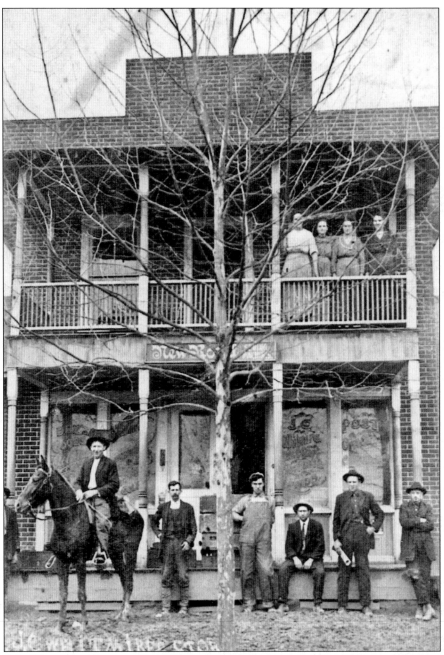

THE J.C. WHITMIRE STORE. The Whitmire store, located on the old Rosman Highway, is photographed here around 1913. The downstairs part of the building operated as a store until 1940. It also housed a post office, until this moved to the depot in 1918. The top story was used as apartments. In 2004, the section of the old Rosman Highway where the store stood was the Old Calvert Road. The ladies on upper porch, are from left to right, Nora Ross (Mrs. Lester) Wilson, Addie Ross (Mrs. John L.) Waldrop, Ola Ross (Mrs. Ben) Hawkins, and Estelle Ross (Mrs. Oat) Bryson. These four ladies were sisters, the daughters of Thomas Jefferson Ross and Martha Peace. (Photo courtesy of Raleigh Waldrop.)

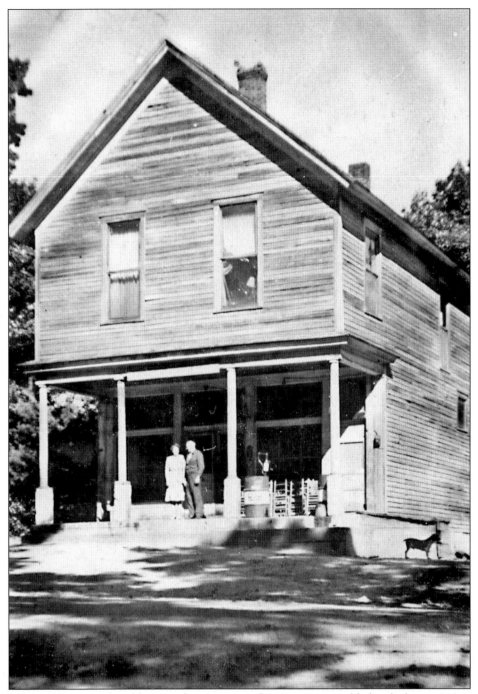

MCNEELY'S STORE. The old McNeely's store in Lake Toxaway stood behind what in 2004 was Haywood Electric. McNeely's was a focal point, as they had the only telephone, Western Union, and post office in the community. Inside the store, you could find among the groceries everything from candy bars and hair color to horse harnesses and farm supplies. Standing on the porch are Walter and Beulah McNeely. (Photo courtesy of Jo Ann Alderman.)

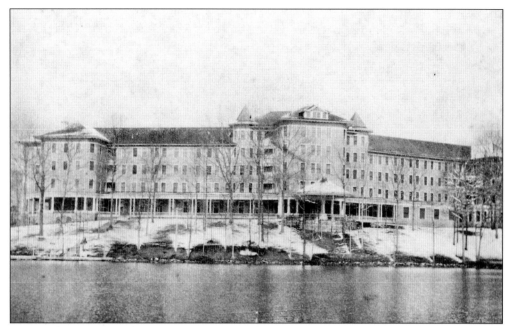

TOXAWAY INN. It was no accident that this resort was completed the same year that the railway reached it in 1903. J. Frances Hayes owned both. The wealthy Pennsylvania industrialist and entrepreneur arrived in the mountains in 1890 for health reasons. He stayed and developed the Toxaway Company, which was responsible for many other fine resorts in the county. Abandoned after the flood of 1916, the building was torn down around 1948. (Photo courtesy of the Historic Preservation Commission.)

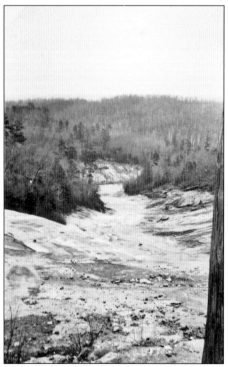

TOXAWAY FALLS AFTER THE FLOOD. Before the Toxaway Dam broke in 1916, the mountainside below it was a terraced, wooded valley with a series of small waterfalls. The torrent of water from a square mile of lake scoured the trees and undergrowth down to the bare rock in a path 350 feet long and 300 feet wide. Some of the trees that fell were pines four feet in diameter. Today the barren rock is the home of Toxaway Falls. (Photo courtesy of Jo Ann Alderman.)

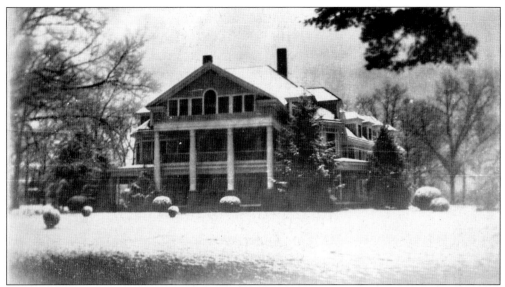

SILVERMONT. Another captain of industry, Joseph Silversteen, came to Transylvania County in 1902. Silversteen was in the tanning business and established the Toxaway Tanning Company in Rosman. He also opened up the Gloucester Lumber Company in 1910. He decided, however, to make Brevard his home and built for his wife Elizabeth and their four daughters this Colonial revival house with 33 rooms. This picture was taken in the 1940s, while Silversteen's last daughter, Dorothy Bjerg, still lived on the estate. Upon her death in 1972, Dorothy willed the mansion to the county and included a trust fund for its maintenance. (Photo courtesy of Jo Ann Alderman.)

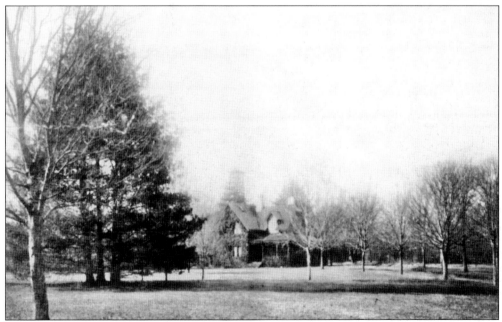

BOARDMAN HOME. Prior to Silversteen acquiring the property, the Boardman home stood on Silvermont's spacious grounds. (Photo courtesy of the Historic Preservation Commission.)

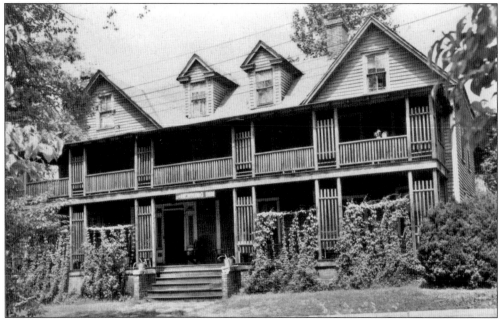

HENNING INN. Boarding houses welcomed new visitors and were a common sight in Transylvania County as the 20th century unfolded. Providing summer accommodations was, and is, an old habit for a community blessed with climate and natural beauty. (Photo courtesy of the Historic Preservation Commission.)

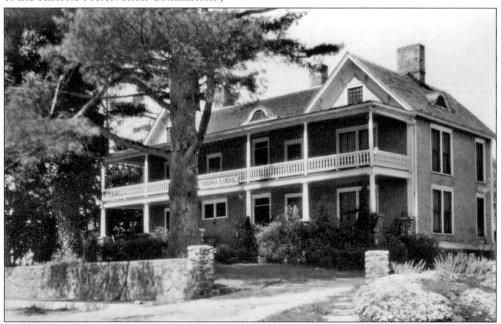

VIRGINIA LODGE. This building lived a long and useful life, starting out as the Transylvania Lodge owned by Maj. William Breese. Breese sold the lodge to Ernest and Virginia Webb, who kept it as a boarding house but with a new name. In its final days, it was the Sharing House, operated by Transylvania Christian Ministry, Inc. (Photo courtesy of the Historic Preservation Commission.)

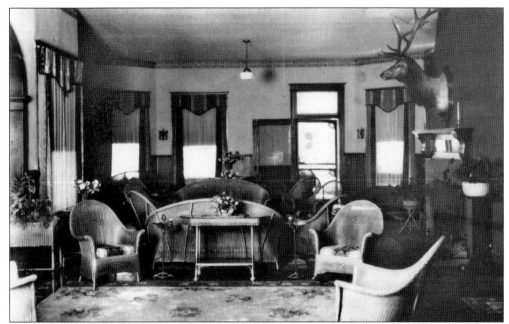

FRANKLIN HOTEL. The Franklin Hotel opened in 1900 with rooms for 200. It was built by J. Frances Hayes as part of an agreement he made with the county commissioners for their support of the bond issue that allowed him to take the railway into Toxaway. The deal served both Brevard and Hayes well, as the Franklin was the grandest hotel to date, providing the most modern and refined accommodations. (Photo courtesy of the Historic Preservation Commission.)

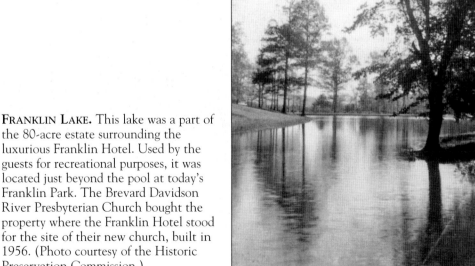

FRANKLIN LAKE. This lake was a part of the 80-acre estate surrounding the luxurious Franklin Hotel. Used by the guests for recreational purposes, it was located just beyond the pool at today's Franklin Park. The Brevard Davidson River Presbyterian Church bought the property where the Franklin Hotel stood for the site of their new church, built in 1956. (Photo courtesy of the Historic Preservation Commission.)

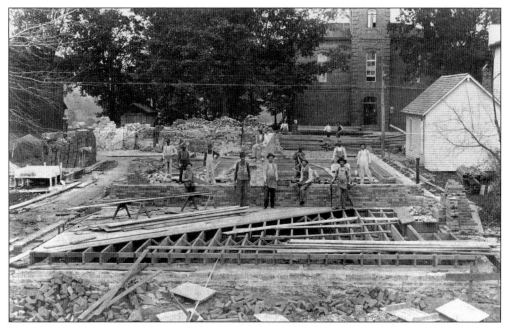

AETHELWALD HOTEL. This picture was taken around 1902 as the Aethelwald underwent construction. A historic landmark of Brevard, the Aethelwald was originally built by John W. McMinn, who named the three-story hotel after his wife. Shops and offices were housed in the main floor with accommodations for 100 above. After World War I, McMinn sold the hotel to T.W. Whitmire, who changed the name to Waltermire in honor of his son. The building was denuded of its third story by order of the fire marshal after the A&P burned. (Photo courtesy of the Historic Preservation Commission.)

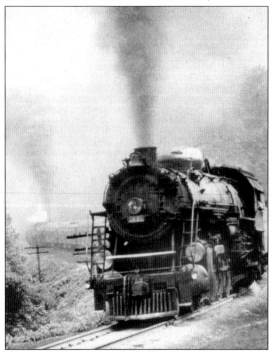

RAILWAY. The coming of the railroad in 1895 brought wealthy industrialists as well as tourists and travelers. Transylvania County began to recover from the economic slump and experienced a level of prosperity previously unknown. (Photo courtesy of the Historic Preservation Commission.)

Three

LOGGING

My old hen's a good old hen, she lays eggs for the railroad men

—"Cluck Old Hen," Traditional

Timber! became the cry of the 20th century, as the logging industry followed on the heels of the railroad. In 1905, Joseph Silversteen purchased over 140,000 acres and built a sawmill in Rosman. Later he added a mill to extract tannin from chestnut. He worked the area for about 30 years. In 1912, the Carr Lumber Company negotiated a 20-year contract with George Vanderbilt to harvest trees from Vanderbilt's estate holdings in what is now Pisgah National Forest. The contract called for "all timber, wood and bark standing and down" on 69,326 acres for $12 an acre. Carr cut everything over 14–16 inches in diameter at the stump. Vanderbilt had begun acquiring land in 1887 and at his death had more than 100,000 acres stretching from just south of Asheville into Mount Pisgah. Louis Carr built a mill in the community of Pisgah Forest beside what used to be the Ecusta plant. Vanderbilt's widow, Edith, offered to sell the Pisgah Forest tract to Louis Carr, but Carr wasn't interested. In 1914, the U.S. Forest Service purchased 78,410 acres from Vanderbilt's widow along with 19,000 acres from Joseph Silversteen, and Pisgah National Forest was born. Carr continued his contract with the government and ran his operation until the 1930s.

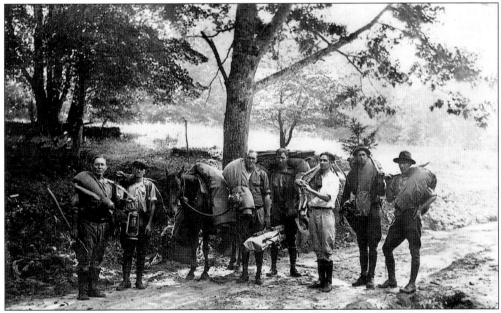

LOGGING CREW. When the logging crew made camp they brought along the tools and supplies necessary for the job. These men are carrying axes, a saw, a lantern, bedrolls, scythes, and a deer for cooking. From left to right are Perry Davis, Clyde Case, Otis Martin, Albert Huffman, ? McNair (assistant supervisor), Charlie Dunn (ranger), and Spurgeon Edmondson. The horse, Charley, was owned by the Case family. (Photo courtesy of Ruth Case Gray.)

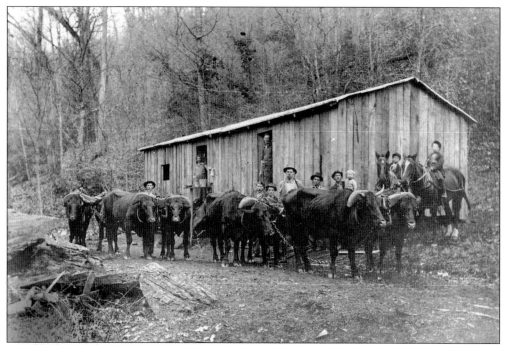

TEAM OF OXEN. The only roads into the forest were wagon roads, including the one that forded Davidson River several times to John's Rock. Logging roads were made by men known as "swampers," whose job was to cut trails for skidders and horses to haul log loads on. (Photo courtesy of the Historic Preservation Commission.)

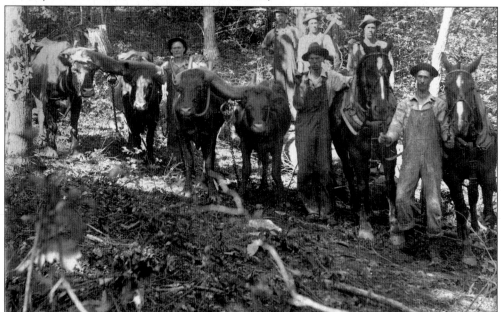

OXEN AND HORSES. Originally, four to six-ox teams were used to haul heavy supply wagons and timber. Later, four-horse teams replaced the oxen in the woods. The four-horse team eventually became a two-horse team—except when they were hauling supplies. (Photo courtesy of Phyllis Cash.)

CHOPPERS. "Lead choppers" cut a notch into trees to show the cutters which ones would be harvested and which way they should fall. Today they are known as sawyers. Tillman Owen is standing on the left in this photo. (Photo courtesy of Phyllis Cash.)

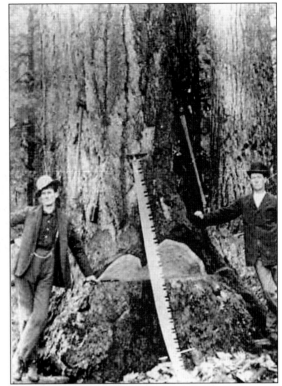

MOVING LOGS. Once the timber was felled and stripped, a "grab jack" was used to hook the trees so they would not run away. A "spreader" was used to load them. A man known as a "road monkey" used a cross-pole to keep the log on the road. A "grab skip" knocked the logs out. (Photo courtesy of Joseph S. Wilde.)

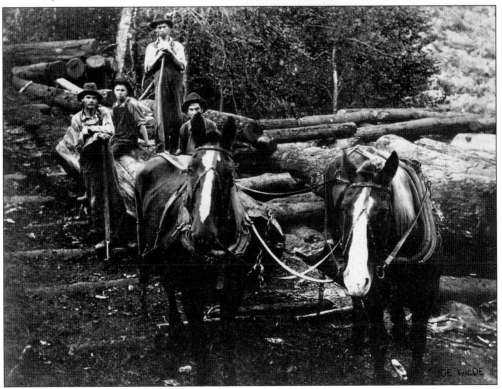

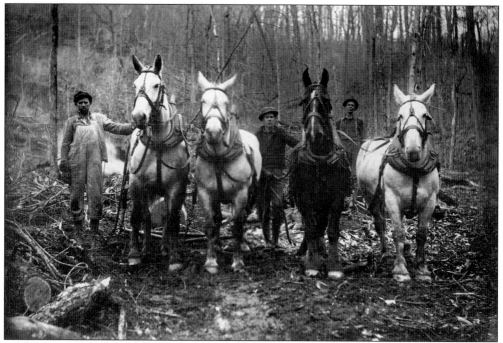

LOGGING HORSES. The horses were as much a part of the camp as the men. A well-cared-for beast could put in a hard day's work, and without their dedicated labor, the job could not be done. (Photo courtesy of Sandy Hoxit.)

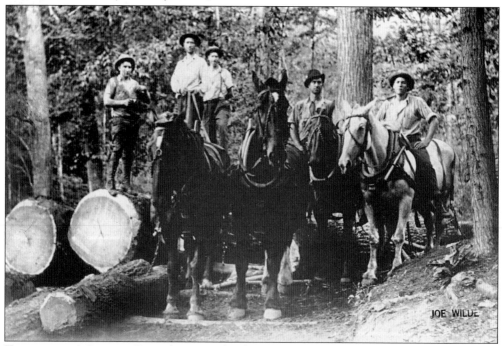

TEAMSTERS. A "teamster" was the man who drove and cared for the horses. The "check line" was the driving reins. The logs transported were around six feet long. (Photo courtesy of Joseph S. Wilde.)

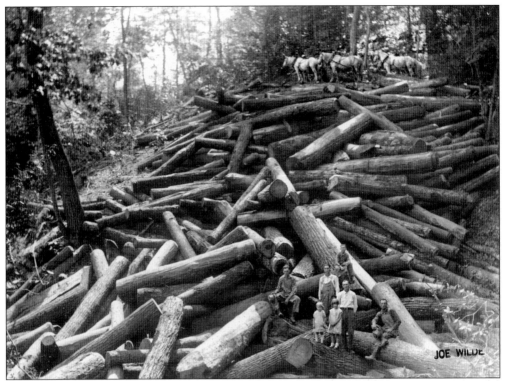

LOG PILE. These logs are staged on a skidway, waiting to be sent to the sawmill. (Photo courtesy of Joseph S. Wilde.)

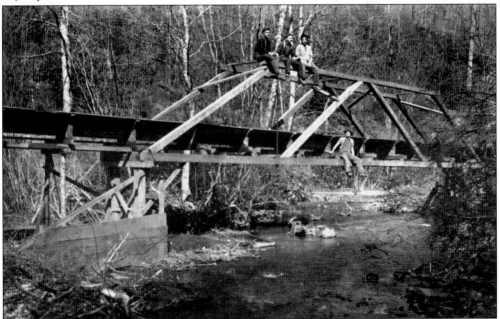

CATHEY'S CREEK TRESTLE. A log flume was used to transport logs from the mountains down to the valleys, where they could be milled. The trestle over this flume is for reinforcement, as the flume crosses the river. (Photo courtesy of the Historic Preservation Commission.)

PINK BEDS. This picture was taken during the summer of 1919, as log loaders worked in the Pink Beds. Before Vanderbilt bought this land, Pink Beds was a small, self-contained mountain farming community. (Photo courtesy of Stephen Lee Sitton.)

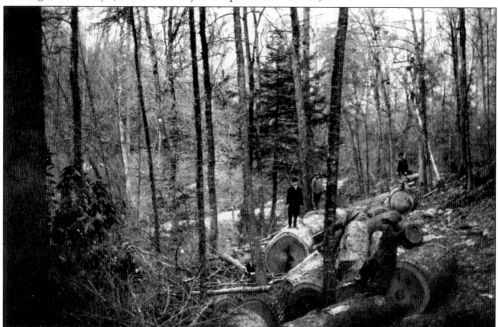

B.J. ESTES. B.J. Estes surveys the virgin timber of Cathey's Creek. Logging practices of the early 1900s depended on who was running the show. Some logging companies left seed-stock—young trees for natural regeneration—while others practiced clear-cutting, which scarred the land, silted the creeks, and destroyed wildlife habitat. (Photo courtesy of the Historic Preservation Commission.)

LOGGING CRANE. Heavy cranes were used to load the timber onto flatcars for transportation to the sawmills. (Photo courtesy of Sandy Hoxit.)

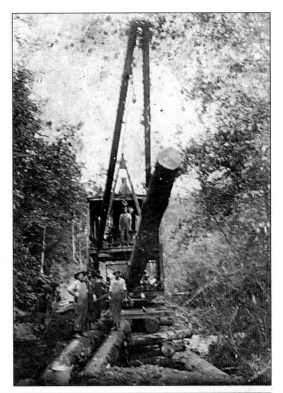

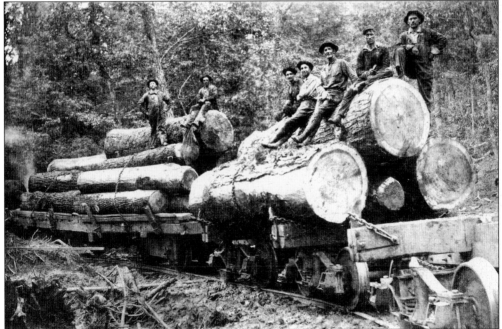

FLATCARS. Pictured on a Carr Lumber Company train are, from left to right on the front car, George Bowen, Jess Hall, Avery Neill, Frank Carr, and Lem Daniels. The men on the second car are unidentified. This picture was taken in the early 1920s. (Photo courtesy of Mary Galyon.)

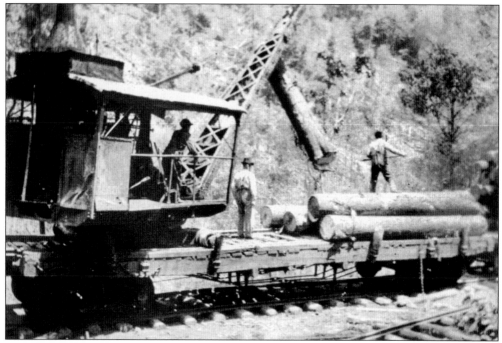

LOADING LOGS. When camp broke, these same cranes and flatbed cars were used to load and transport the logging shacks. (Photo courtesy of the Historic Preservation Commission.)

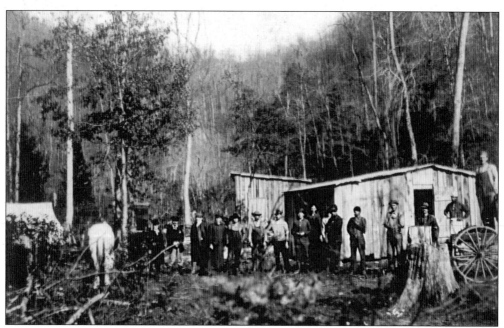

CATHEY'S CREEK LOGGING CAMP. Most logging families lived in camps and followed the timber. The housing in which they dwelt only had two rooms. The houses were furnished with homemade tables, cane bottomed chairs, and iron bedsteads. This photograph was taken in 1908. (Photo courtesy of the Historic Preservation Commission.)

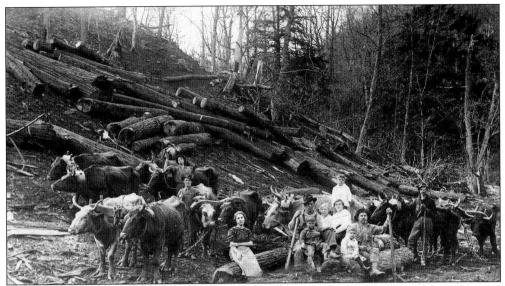

CAMP COOK. Every camp was reliant on the woman who provided the daily meals and doubled as the camp medic. Julia Galloway Robinson, sitting in front on the log, was the cook of this camp. Breakfast usually consisted of biscuits, "sawmill" gravy, and plenty of coffee. (Photo courtesy of Phyllis Cash.)

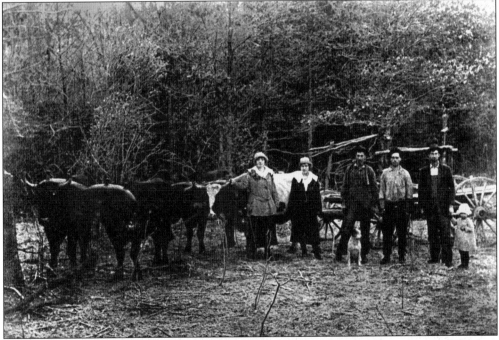

LESLIE LOGGING CAMP. Located near John's Rock, Leslie Logging Camp was operated for Carr Lumber Company by Henry Leslie from Glasgow, Scotland. Henry was married to Susan A. Summey. His children are, from left to right, Jane Leslie (married Leo Lenoir Morris), Ann Leslie (married Clyde Case), and Albert Leslie (did not marry); workers Fred Merritt and Elzie and Fay Galloway complete the picture. Albert has oxen and wagon ready to go for feed. This picture was taken around 1916–1917. (Photo courtesy of Ruth Case Gray.)

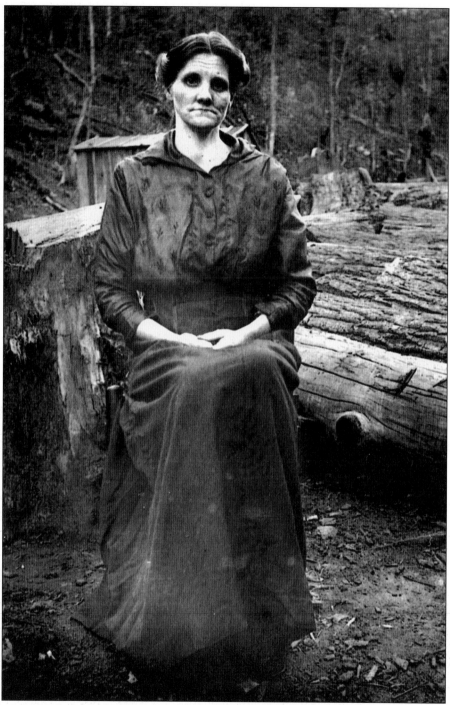

NANIE ALLEN. Life in a logging camp was hard for the women who made their homes in crude shacks with sparse belongings and furniture. The education of their children was always a concern, and many women set up schools for the camp's children. If they were lucky, there was a church in the area that could double as a schoolroom. Sometimes schools were conducted in a boxcar left at the camp. (Photo courtesy of Cubby Griffin.)

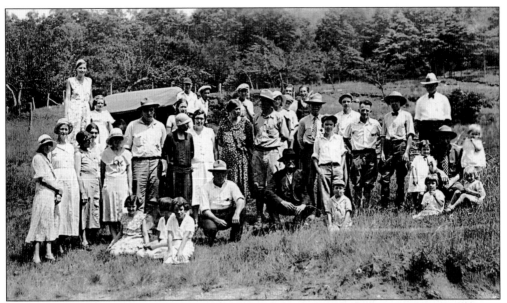

PISGAH FOREST FAMILIES. The above photo, taken *c.* 1920s–1930s, includes the following: (from left to right at the road) Maude Cansler, Bertha Wilson, Allie Davis, Julia Leslie, Mary Ann Case, Bill Duncan, Jessie ?, Avor Duncan, Bertha Huffman, Albert Huffman, Charlie Wilson, Ed Sentell, Clyde Case, Bob Cansler, and ? Clark; (foreground, first row) Helen Duncan, Ruth Duncan, Billie Jean Duncan, Wilburn Davis, Roger Cansler, Tom Huffman, and unidentified girls; (second row) Bertha Huffman, R. Case, Jack Davis, Homer Huffman, Margy Davis Sentell, Harry Sitton, and "Boo" Davis. (Photo courtesy of Ruth Case Gray.)

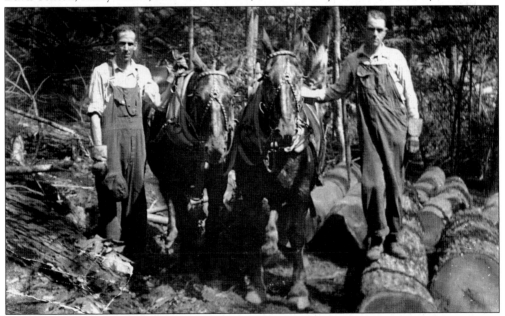

TOM ENGLISH LOGGING. Tom English, left, was one of 11 children born to Weldon and Alice Cagle English. He worked for Chris Dillard on Avery Creek. He was a blacksmith and made grab shoes, grab skips, and grab jacks. The ringing of the hammer and anvil was a steady background to the men felling trees. (Photo courtesy of Sandy Hoxit.)

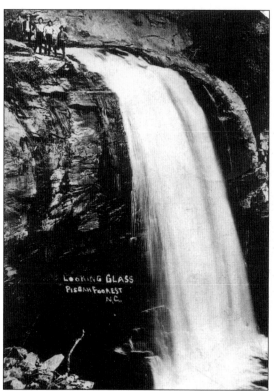

LOOKING GLASS FALLS. The logging railroad ran right past Looking Glass at an eight to nine percent grade. The current highway follows the old railroad bed. (Photo courtesy of Cecil Leslie.)

BRAKEMAN. The brakeman had one of the most important jobs on the train. Here, Lem Daniels, standing on the far left, is the brakeman. To his right are John Buckner, Harkless Hensley, and Charles Buckner. The engine shown is a Climax engine. The first car behind it hauled split sections of chestnut, debarked for pulpwood. (Photo courtesy of Mary Galyon.)

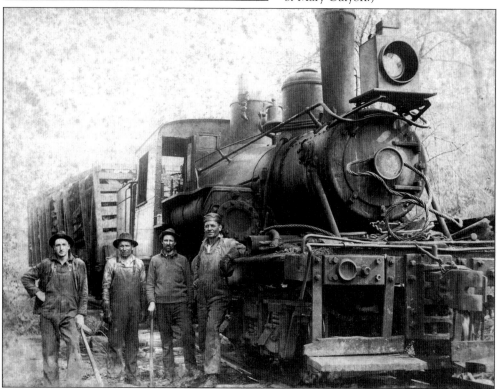

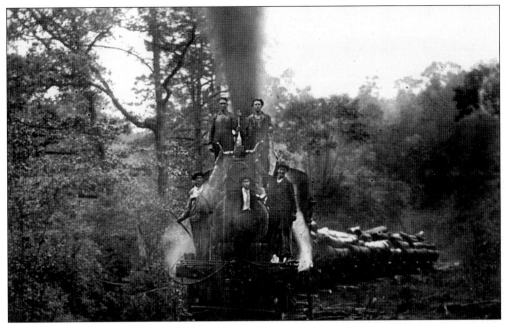

RIDING THE RAIL. Trains traveling down steep inclines ran the risk of becoming runaway trains. When this happened, the engineer would give a signal to the men, who were forced to jump for their lives. (Photo courtesy of the Historic Preservation Commission.)

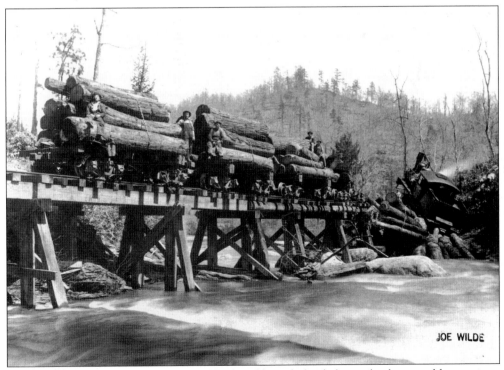

BRIDGE WRECK. Under the constant weight of heavily loaded cars, bridges would sometimes collapse, as shown here. (Photo courtesy of Joseph S. Wilde.)

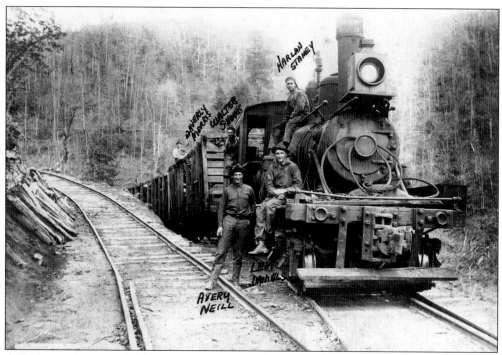

CARR LUMBER COMPANY TRAIN. Waverly Morris is the young boy at left in front of an unidentified man, Walter Shook has his head out the cab window, Harlan Stamey is on top of engine, Lem Daniels is on the side of engine, and Avery Neill is standing on the tracks. (Photo courtesy of Mary Galyon.)

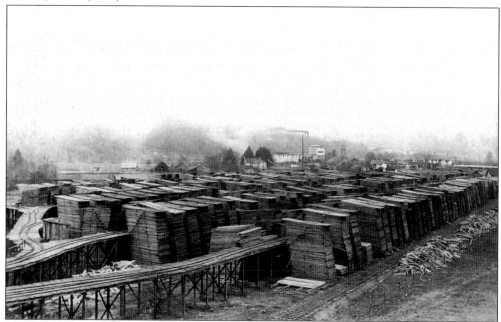

CARR LUMBER COMPANY. Shown here is a view from the sawmill in Pisgah Forest of the planing mill and lumberyard. The Patton House can be seen in the center background on old Highway 64. This picture was taken in the 1920s. (Photo courtesy of Mary Galyon.)

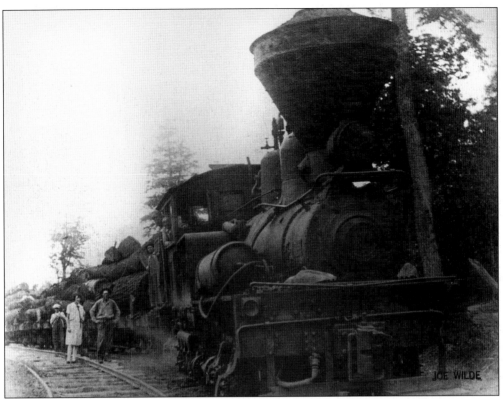

MOLTZ LUMBER. The Moltz Lumber Company had a large band-saw mill in Lake Toxaway. They used the Shay engines for transportation of the heavy loads up steep grades. (Photo courtesy of the Historic Preservation Commission.)

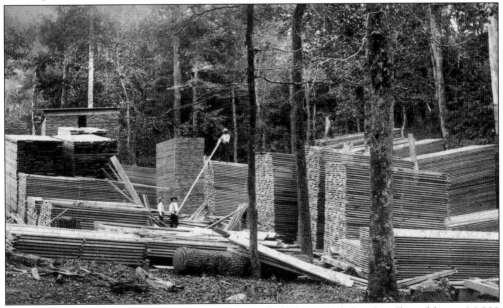

LUMBER YARD AT SAPPHIRE. A seven-and-one-half-foot Clark band mill could saw 26,000 board feet of lumber in a day. (Photo courtesy of the Historic Preservation Commission.)

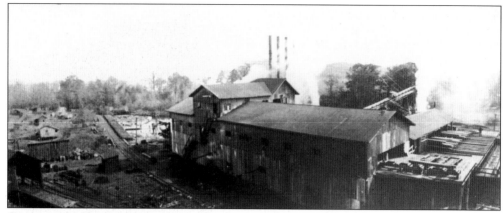

GLOUCESTER LUMBER COMPANY. Timber was harvested on the hills surrounding the headwaters of the French Broad River. Toxaway Tanning Company also derived their business from the logging industry by manufacturing tannin from the bark of chestnut, hemlock, and chestnut oak. Tannin was used in the manufacturing of leather. (Photo courtesy of the Historic Preservation Commission.)

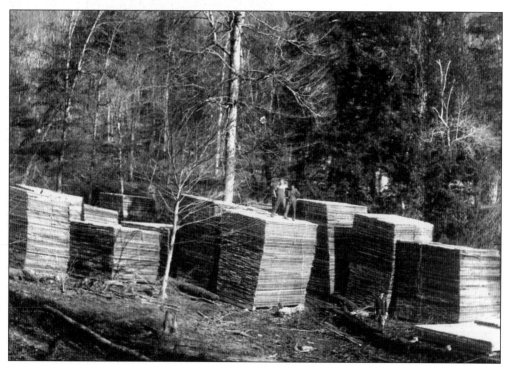

LUMBER YARD. Men took pride in the amount of lumber they made in a day, knowing these boards would be used for the building of homes, schools, and churches. (Photo courtesy of the Historic Preservation Commission.)

ROSMAN EXTRACT COMPANY. Rosman Extract was another of Joseph Silversteen's companies. Because it lay adjacent to the forest and was close to the east, west, and north forks of the French Broad River, it was ideal for the timber business. (Photo courtesy of the Historic Preservation Commission.)

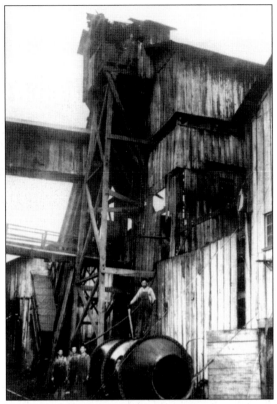

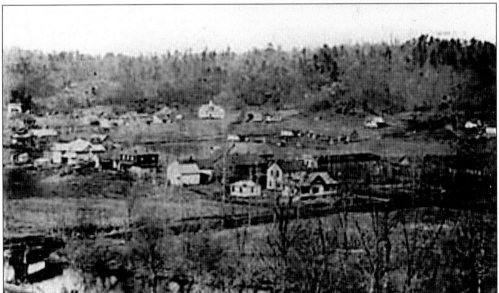

ROSMAN IN 1914. Known first as Jeptha, Rosman became known as Toxaway in 1901. This caused confusion with Lake Toxaway, so in 1903 the name was changed to Eastatoe. The citizens were not overly fond of the name, so Joseph Silvesteen christened the town Rosman in 1905. The name was pulled from two of Silversteen's business associates, Joseph Rosenthal and Morris Osmansky. (Photo courtesy of Elvin Holden.)

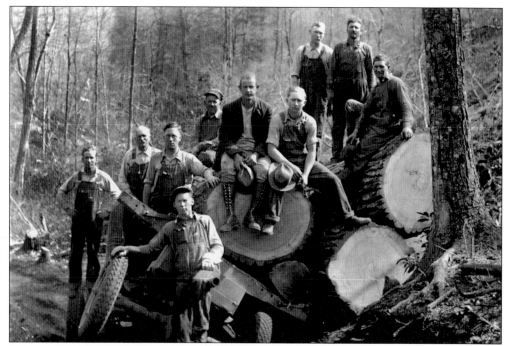

TRUCK WRECK. The diameter of the huge timber was often too much of a challenge for early-model trucks. In a situation such as this, the load shifted and took the vehicle with it. Glen Galloway stands in front of the wreck. (Photo courtesy of Phyllis Cash.)

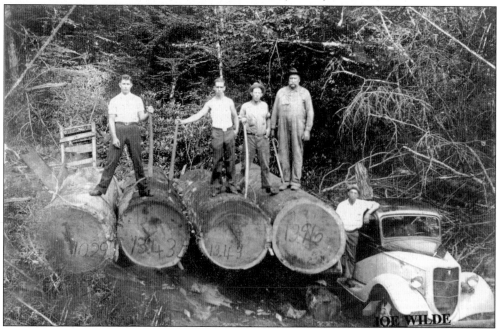

T.J. WOOD. Standing on the right of the logs is Big Tom Wood, who worked in the logging business for many years. Tom was also the sheriff at one time. He was almost seven feet tall and weighed over 330 pounds. He could span a double-bit axe with one hand. His son Rufus is the man on the far right by the car. (Photo courtesy of Joseph S. Wilde.)

54

Four

FAMILIES

The blackest crow that ever flew would surely turn to white
if ever I prove false to you bright day will turn to night

—"The Blackest Crow," Traditional

Families are the backbone of any community. Transylvania County has been influenced by many cultures, but one of the strongest is the Scotch-Irish. When the first settlers migrated into the Blue Ridge section of what is now Transylvania County, they brought with them the spirit, knowledge, and customs of their motherlands. As they made their home in the heart of the mountains, they melted together to form a race of people who claimed the land as their own. They worked it, fought wars over it, improved it, and passed it along to their children. They labored for what they got, looked to God for strength and comfort, and never turned away a man they could help. They instilled these beliefs in their children and raised them on pride and hard work. These native sons and daughters remain in the area today and still believe in the justice of God, the fruits of labor, and the humanity of mankind.

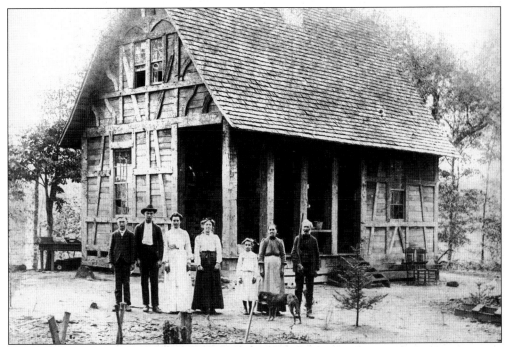

JESSIE MILES MCCALL AND FAMILY. Riley McCall and Hulda married on August 6, 1905. From left to right are Henson, Riley, Hulda, Harriet (Perdie), Bell, Lavina (Viney) Garren, and Jesse Miles McCall. Jessie and Viney were caretakers of the original Black Forest Lodge in Balsam Grove, while Jessie was a forest watchman. The lodges were copies of those Carl Schenck had known in Germany. Dr. Schenck established the first school of forestry in the United States. (Photo courtesy of Cecil Leslie.)

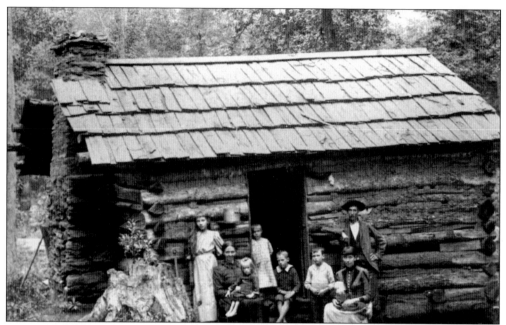

PIONEER CABINS. Poplar logs were used for log cabins because they were the straightest. Often small poles could be placed in between the logs to help fill the cracks. After this, mud was used to "chink and daub," creating an airtight wall. A puncheon floor was made by splitting logs in half and laying them cut side up. The fireplace was built of rock, using at least a six-foot long rock for the mantle. Shingles were made from oak and chestnut. A drawing knife was used to smooth them. Doors were assembled with wooden pegs. Square nails were not used until after the 1900s. (Photo courtesy of the Historic Preservation Commission.)

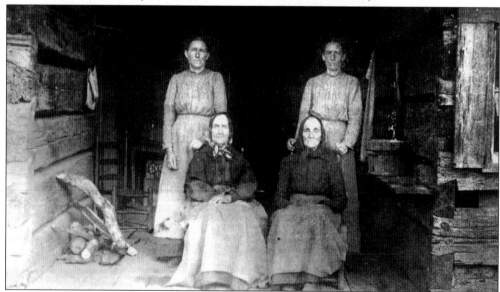

DOG TROT CABIN. A "dog trot" cabin was so called because the breezeway that connected the kitchen to the rest of the cabin was a perfect thoroughfare for the family hounds. The kitchen was often separated from living quarters in case of fire. The women above belong to the McCall and Webb families. (Photo courtesy of Rena' Bateman.)

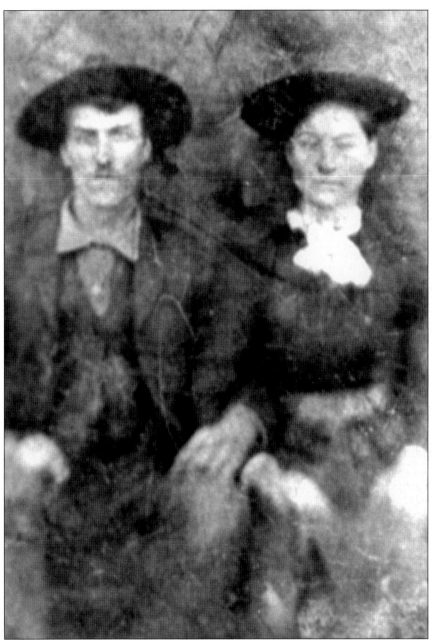

JOHN OWEN II AND LAVINIA PARKER OWEN. Born in 1794 and raised in the Cherryfield section of Transylvania County, John Owen was something of a land baron. He bought his first tract of land—50 acres on Burnt Cabin Branch—while still a young man. He wanted it for the springs located on it. In 1815, he purchased "From the top of Wolf Mountain down through the Canada section and beyond." Upon his marriage to Lavinia Parker, John bought from a Cherokee couple a large tract in Gloucester where he built his home. He and Lavinia reared 15 children there. Upon his mother's death, John inherited land in the Cherryfield section. He already owned other land there and sold both tracts, living on the farm in Gloucester until his death in 1876. (Photo courtesy of Toni McCall.)

LETTIE OWEN AND KETURA GALLOWAY. Lettie Owen was the daughter of James Milford Owen and Dovie Elizabeth Mathis. She married Louie McCall. Ketura Galloway was the daughter of Otho Morgan Galloway and Betsie Elizabeth Dunn. She married Cecil Green. They are pictured, along with an unidentified child, in front of one of the main crops grown in the area—corn. Fresh, it was eaten cut off or on the cob; dried, it was used for cornmeal, grits, and hominy; sprouted, it was used for moonshine. The shucks were used for everything from horse collars to mattress ticking to chair bottoms and hats. The dried fodder was used to feed the animals. (Photo courtesy of Phyllis Cash.)

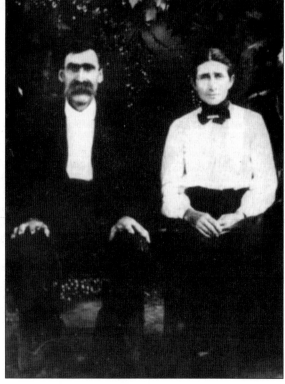

ISAIAH "SLICK" FISHER AND CAROLINE LEE FISHER. Slick Fisher was born in 1851 and lived in the upper part of the county, on property acquired by a land grant. A farmer all of his life, he died at the age of 85 while saddling his horse to go feed the pigs. His wife, Caroline, made quilts for many families and was instrumental in teaching the craft to others. (Photo courtesy of Jo Ann Alderman.)

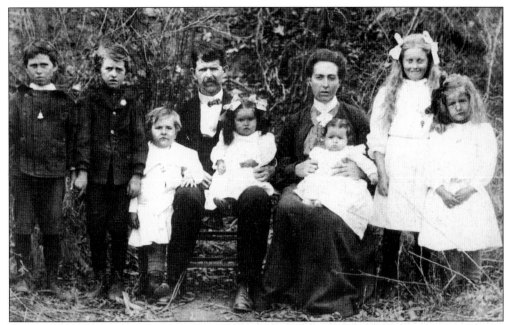

THE PHILYAR GALLOWAY AND MARY MCCALL FAMILY. Pictured around 1909, the Galloways are, from left to right, Alga, Larry, Bill, Philyar (holding Edith), Mary (holding Marie), Sadie, and Judy. Gladys and Lavada were not born yet. Mary was the daughter of Enos McCall and Sarah Jane Wood. Philyar was the son of Clifford Galloway and Lucretia Jane Pernetta Owen. (Photo courtesy of Betty Davis.)

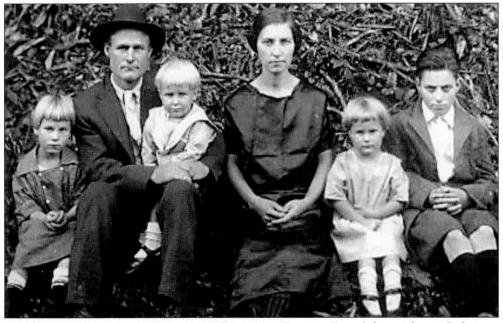

THE WALTER FISHER AND JULIA ANN GALLOWAY FAMILY. From left to right are Dohonov, Walter (holding Lawrence), Julia Ann Galloway, Lowee, and Ira Robinson. Walter Fisher was the son of Simpson McDonald Fisher and Mary Etta Lee. Julia Ann was the daughter of Otho Morgan Galloway and Betsie Elizabeth Dunn. (Photo courtesy of Phyllis Cash.)

GEORGE WASHINGTON ABRAHAM LINCOLN "LINK" MCCALL. Link was the son of William M. McCall and Mary Owen. He was born in 1861, when Abraham Lincoln was President. It was a common practice to name a later son after a man of renown, the first sons usually carrying on family names. Link's father owned a gristmill in Gloucester, and all of his sons knew a thing or two about grinding meal. Most families grew their own grain. Rye was raised more than wheat, and it was beaten, thrashed, and flailed with a two-foot-long flail. The flail had a five-foot-long handle and was connected by a leather strap. (Photo courtesy of Herschel Owen.)

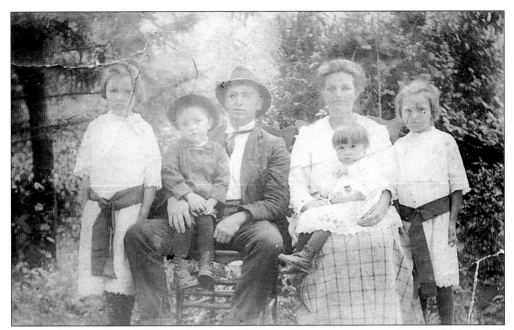

THE RILEY AND HULDA McCALL FAMILY. William Riley was the son of Jessie Miles McCall and Lavinia Elvina Garren. Riley was a firewatcher on Pilot Mountain. He rode a mule to work and sometimes took his daughter Stella along to spend the day. From left to right are Viola, Riley (holding Carter), Hulda (holding Stella), and Ada. This picture was taken around 1920. (Photo courtesy of Rena' Bateman.)

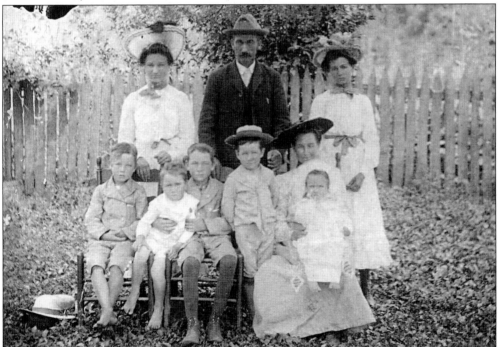

THE DOCK AND SISSY McCALL FAMILY. Dock was the son of William M. McCall and Mary Owen. Dock and Sissy farmed for a living. (Photo courtesy of Stanford McCall.)

HESTER HOWARD OWEN AND DAUGHTER EDNA OWEN. Hester, right, was married to Henry Madison "Matt" Owen, son of Tillman Owen and Sallie Parker. Her daughter Edna married Zollie Dexter Shelton. Here they are shown with the family horses—animals no farm could do without. Horses had their own social order, as some were used for riding and some for plowing, depending on the breed. Plowing was done with a "turn plow," which was used to dig up the earth. A "double foot plow" was used as a rotor-tiller. A "drag hair" was used to smooth the ground down after plowing. It was commonly made from the forks of a crabapple tree, which had been cut and filled with pegs. A "bull tongue" plow was a single-blade plow used for furrowing. The rich soil yielded corn, potatoes, and cabbage as main crops, with every family keeping a "kitchen" garden to provided a number of vegetables for the table. (Photo courtesy of Phyllis Cash.)

COLUMBUS SINIARD. From left to right are Elizabeth "Lizzie" Wilson Fortune, Columbus Millard Siniard, and wife Lillie Elvira Mackey Siniard. Columbus Siniard owned approximately 200 acres in the area of today's Deer Lake, a part of the homestead on which he was born. (Photo courtesy of Jo Ann Bryson.)

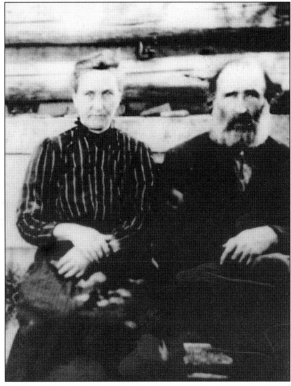

PERRY COLUMBUS HAMLIN AND MARY DUNN MASON HAMLIN. Mary Etta Dunn was the daughter of Rev. William Coffey Dunn and Anna Jane Nicholson. (Photo courtesy of Mildred Shular Lee.)

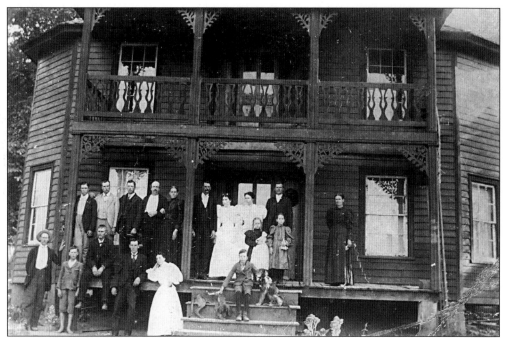

THE TINSLEY FAMILY. The family pictured above lived on Island Ford Road. The first Tinsleys to settle in Transylvania County in the 1820s made their home in the Cathey's Creek area. (Photo courtesy of the Historic Preservation Commission.)

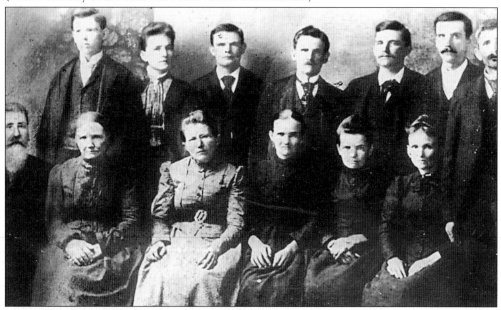

THE ANDREW JACKSON LYDAY FAMILY. The Lyday family had been in residence for around 90 years when Transylvania County was formed. They owned land in Lyday Creek, formally known as Haystack Branch. A.J. Lyday (1824–1890) was the first doctor in the county, and he performed the first surgery using anaesthesia. He used a log cabin built beside his home as his office. Two of his sons, Dr. Bill Lyday and Dr. Elliot Lyday, followed in his footsteps. "Doc" Lyday was married to Elizabeth Clayton. (Photo courtesy of Stephen Lee Sitton.)

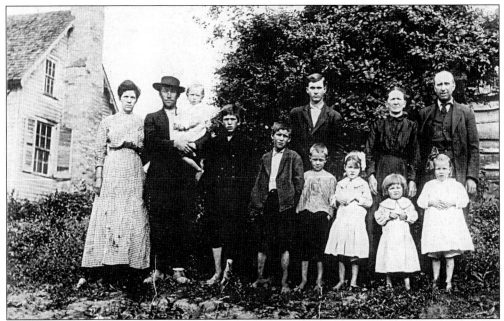

THE LANCE FAMILY. From left to right are (front row) Ella Harriet Hogsed Lace, Charles Manning Lance Sr., William Arlin Lance, Dewey Lance, Mitchell Lance, Frank M. Lance, Laroue Lance, Sanobe Lance, and Gertie Louise Lance; (back row) Robert Lance, Martha Jane Batson Lance, and Joseph Anderson Lance. This picture was made at the Sunny Side Dairy on Country Club Road. The home is no longer there. (Photo courtesy of Jean and Leon Pace.)

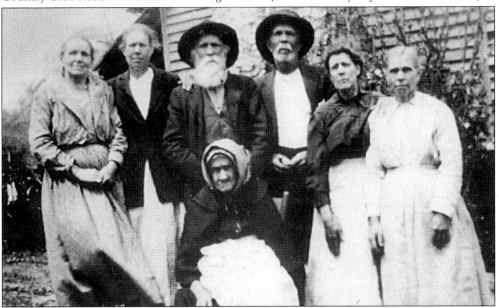

THE SAMUEL HOGSED FAMILY. Seated in front is Dorcas Caroline Hefner Hogsed, wife of Samuel Hogsed and daughter of Phillip and Cynthia Parris Hefner. Her children, from left to right, are Easter Caroline, Alice, Riley, William, Emma, and Rachel. This c. 1930s picture was taken at the old homestead behind Dunn's Rock Baptist Church. During the Civil War, Samuel carried messages between Brevard and Asheville. (Photo courtesy of Jean and Leon Pace.)

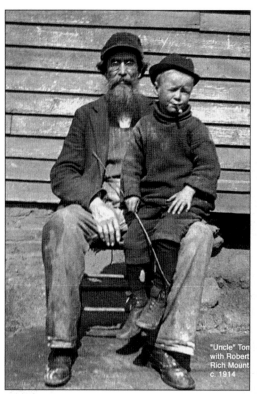

"Uncle" Tom
with Robert
Rich Mount
c. 1914

TOM FOWLER. Robert Willimon is seated on Tom Fowler's lap in this *c.* 1914 image, taken on Rich Mountain. Many families in this area raised hogs to sell, and they let them feed in the woods throughout the summer. Every fall, the fattened hogs were rounded up and driven to market in South Carolina. A frequent overnight stop was in Little River, which is how Hogtown got its name. Here the drovers would rest, eat, and usually hold a dance. (Photo courtesy of John and Lelia von Stein.)

WILLIAM HENRY ABRAHAM WILLIMON. Dark colors dominated men's clothing during the late 1800s. A cutaway frock coat was stylish for day and evening. Celluloid collars were used when dressing up. Men kept fairly short hair and wore beards or handlebar mustaches, which they waxed. Everyday dress consisted of wool britches and wool shirts. Levi jeans were also widely popular. (Photo courtesy of John and Lelia von Stein.)

IDA MCCALL MCCRARY. Ida McCall was from Little River. She married Virgil McCrary, also from Little River. (Photo courtesy of Kathleen Moore.)

THE MALINDA MCCALL AND CHARLES OSTEEN FAMILY. Malinda "Lind" McCall was the daughter of John Jasper McCall and Mary Emily Shipman. Charles Osteen was the son of Edward Osteen and Jane McMinn. (Photo courtesy of Gary King.)

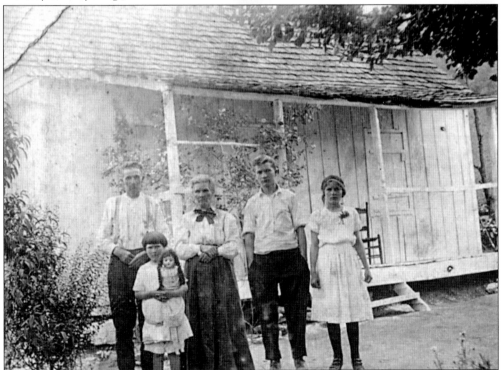

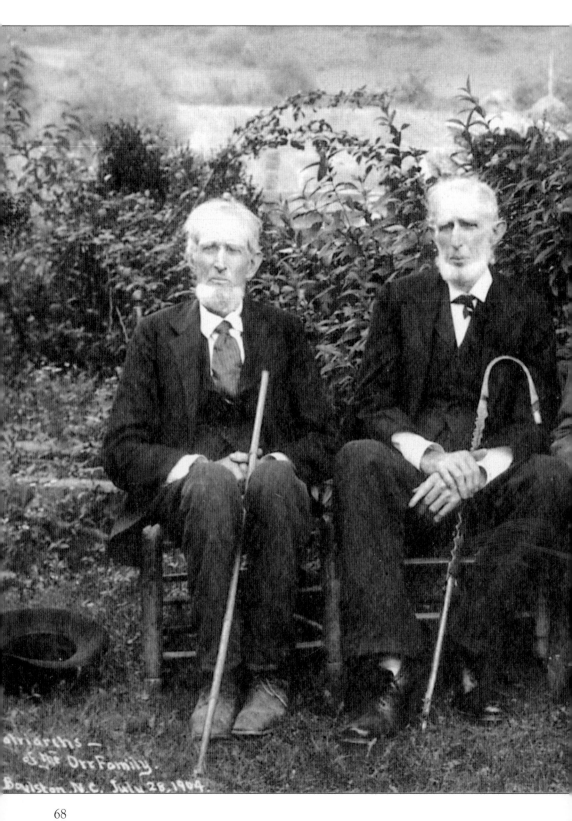

Patriarchs —
of the Orr Family.
Boviston N.C. July 28, 1904.

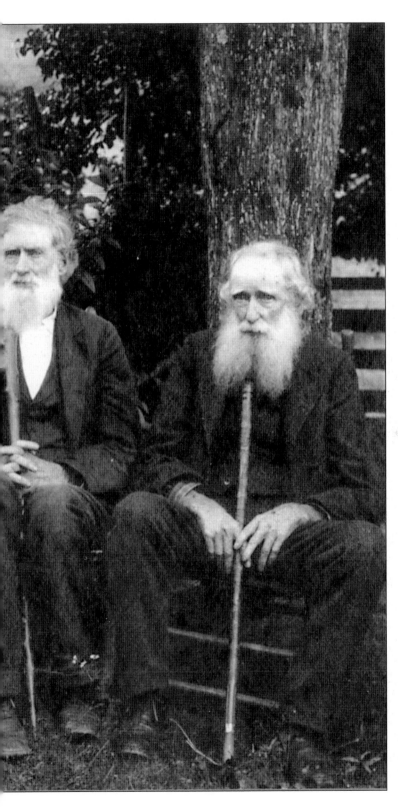

PATRIARCHS OF THE ORR FAMILY. This picture was taken in Boyleston on July 28, 1904. Seated, from left to right, are Samuel Orr (1820–1904), Joshua Orr (1824–1910), Jason Orr (1826–1907), and Gideon Orr (1828–1905). They are all sons of John Orr and Jane Clayton, who had 15 children all told. Samuel Orr married Elizabeth Fletcher, Joshua Orr married Jane Cagle, Jason Orr married Matilda Hadden, and Gideon Orr married Mintie Dawson. (Photo courtesy of Stephen Lee Sitton.)

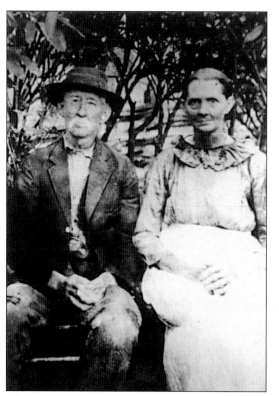

ISAIAH AND MARTHA ELMINIA MASON OWEN. Isaiah was the son of Andrew Jackson Owen and Mary Ann McCall. Elminia was the daughter of Rev. Martin Mason and Nancy Bracken. She was one of the many mountain women who made her own soap. Hickory-wood ashes were placed in a hollowed-out block of wood with a small hole in the bottom. Water was poured over the ashes, and lye dripped through the hole into a glass or stone container. Fat from a butchered farm animal was placed in a kettle over an open fire. The lye was poured over the fat, eating the fat up and producing soap. (Photo courtesy of Gwen Ashe.)

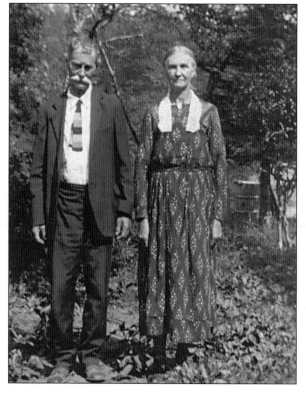

RUFUS MCCALL AND PERNETTA OWEN. Rufus was the son of Jason McCall and Margaret Matilda Dunn. Pernetta was the daughter of William Baxter Owen and Sarah H. Whitmire. (Photo courtesy of Linda McCall.)

REV. MARTIN MASON. Martin Mason moved to Gloucester in 1823 from Troublesome Creek, in Campbell County, Virginia. He became the first pastor of the Macedonia Baptist Church when it broke from the Cathey's Creek Baptist Church in 1842. The break was not only for convenience; the settlers in the Upper French Broad area did not agree with the politics of the lower basin. Reverend Mason lived at the head of Mason's Creek in Gloucester. (Photo courtesy of Michael Mason.)

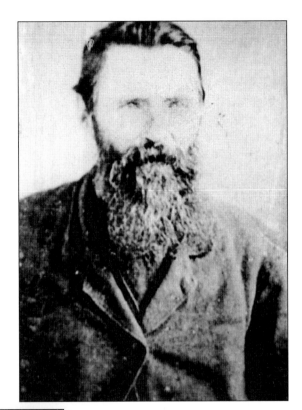

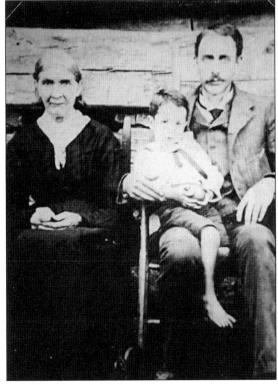

NANCY BRACKEN. Pictured is Nancy Bracken Mason with her youngest son John Mason, holding his son Roy. Nancy was the daughter of Thomas Bracken and Elizabeth Kitchens. After the death of her husband, Rev. Martin Mason, Nancy sold the land on Mason's Creek. (Photo courtesy of Michael Mason.)

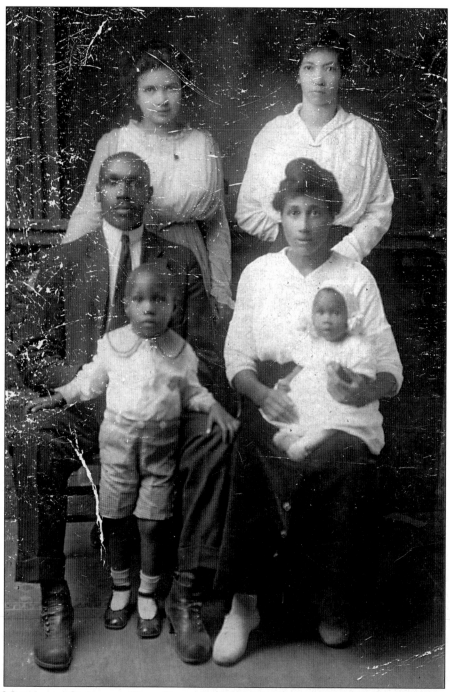

THE MOSES AND GERTRUDE GASH FAMILY. Standing in front of Moses is son Ueral. Gertrude is holding daughter Jennie V. The ladies in the back are unidentified. (Photo courtesy of Doyce Jeter.)

DILLARD MCCALL AND ELIZABETH OWEN.
Dillard was the son of Jessie Miles McCall and
Lavinia Elvina Garren. Elizabeth was the daughter
of Thomas Clingman Owen and Thanie Ann
Mason. (Photo courtesy of Betty Davis.)

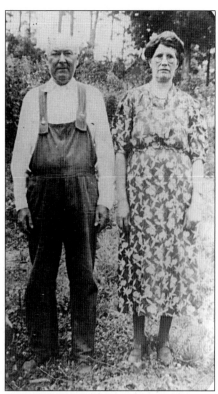

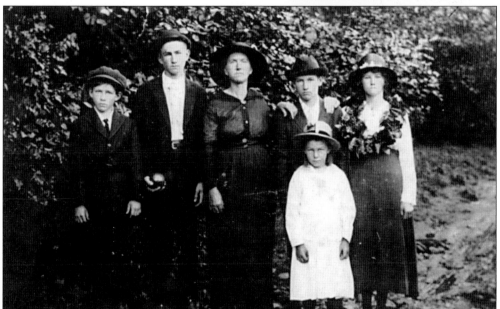

ROXIE DUNN MCCALL AND FAMILY. Roxie was licensed by Dr. Summey as a midwife and delivered many babies in upper Transylvania County. She went during all hours and in all kinds of weather. She would stay with the family until mother and baby were resting comfortably. For her labors she was usually paid in poultry, ham, or other meats. Roxie was the daughter of Rev. W.C. Dunn and Anna Jane Nicholson. (Photo courtesy of Kaye McCall Owenby.)

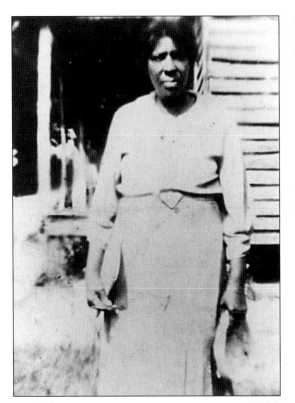

LELA BENJAMIN. This picture was taken near Lela's home on North Lane Street around 1920. (Photo courtesy of the Historic Preservation Commission.)

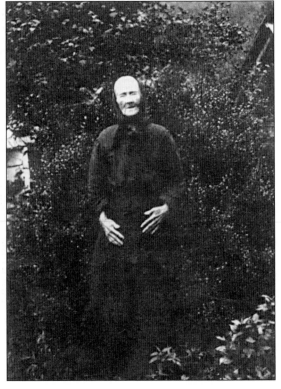

EASTER "HETTIE" MCCALL. Hettie was the daughter of John A. McCall and Elizabeth Glazner. She married James Marion Owen. When Hettie was growing up, almost all clothing was made by hand. Fresh wool was washed in the creek, carded on combs, and spun into yarn on the spinning wheel. The yarn was woven on a loom to make lindsey cloth. They made brown dye from walnut, black from butternut, lavender from pokeberries, yellow from hickory, and reds or pinks from madder. This picture was taken around 1919. (Photo courtesy of Rena' Bateman.)

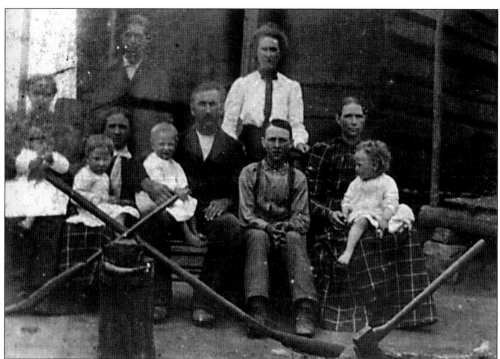

THE WILLIAM BAXTER OWEN AND MARY WOOD FAMILY. Baxter Owen placed his guns out for this picture, as it was customary to photograph your prize possessions along with your family. It has often been said that the long rifle secured America's quest for freedom. The elongated barrel had superior range and accuracy, and it reduced the amount of lead used for bullets. The rifle was approximately .50-caliber. (Photo courtesy of Doris Owen Jones.)

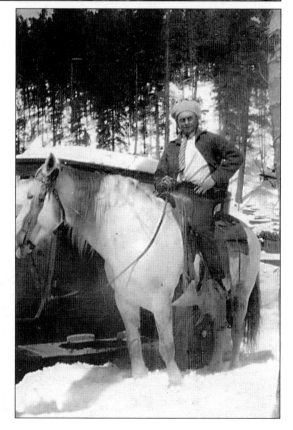

GEORGE MCCALL. Pictured here on his steed, George was the son of Ananias C. McCall and Sally Sharpe. The versatility of the horse made it a prized asset. The horse plowed fields, pulled wagons and carriages, and was an essential part of any rural economy. The loss of a small farmer's horse frequently meant his ruin. (Photo courtesy of David McCall.)

ELIZABETH COWART CHASTAIN. Picture taking was almost unheard of in the mountains until 1839, when a new phase in photography produced a one-of-a-kind picture on metal, the daguerreotype. Even through the end of the century, people considered having their portrait made serious business, and no one smiled. The lack of frown wrinkles in Elizabeth's forehead would indicate a pleasant personality. (Photo courtesy of Toni McCall and Glenda Maxwell Simpson.)

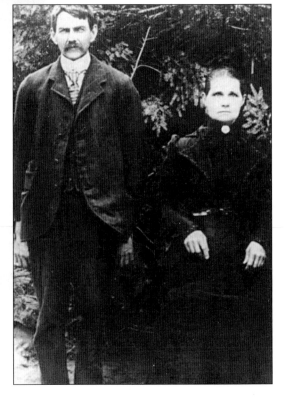

JOHN ALMIE McCALL AND ERSLIE BANTHER. Erslie's father, Mike Banther, was a blacksmith—a valued trade in the mountains. Not only did they shoe horses, they also built wagons, made wagon-wheel rims, and conducted repairs. There was also a demand for plows, hardware, house wares, and sometimes rifles. Many blacksmiths were also considered gunsmiths. (Photo courtesy of Rena' Bateman.)

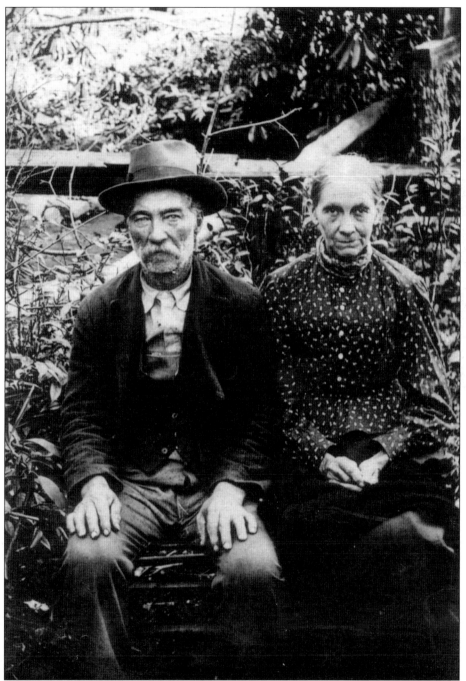

Thomas Clingman Owen and Thanie Ann Mason. Thomas Clingman Owen was the son of Andrew Jackson Owen and Mary Ann McCall. Thanie Ann was the daughter of Rev. Martin Mason and Nancy Bracken. They were both born in 1858, the same year Minnesota was admitted into the United States and the first message over transatlantic cable was sent. They had 11 children who lived and married close to home, making the family a tight-knit group. (Photo courtesy of Linda McCall.)

JANE SHEPARD MCCALL. Jane was the daughter of Calvin Grandison Shepard and Ferribee Ammons. She was born the same year Transylvania County was formed and died during the Depression. She was married to Link McCall and had eight children. This picture with Jane's grandchildren was taken around 1918. (Photo courtesy of Hershel Owen.)

JOHN ASBURY OWEN AND LAVANDA LEDFORD FAMILY. John was the son of Jimmie Owen and Betty Parker. He was born in 1845, when Texas and Florida were admitted to the United States. James Polk was president, and Stephen Foster had just written "Oh! Susanna," which became a favorite of the 49ers during the gold rush. (Photo courtesy of Rena' Bateman.)

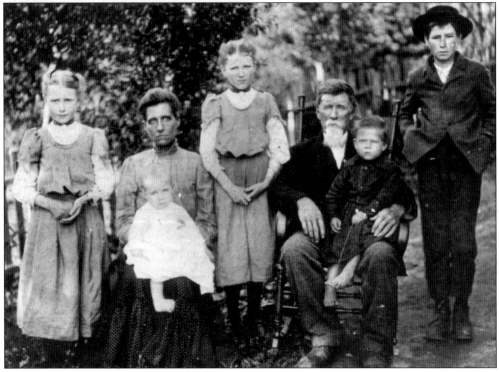

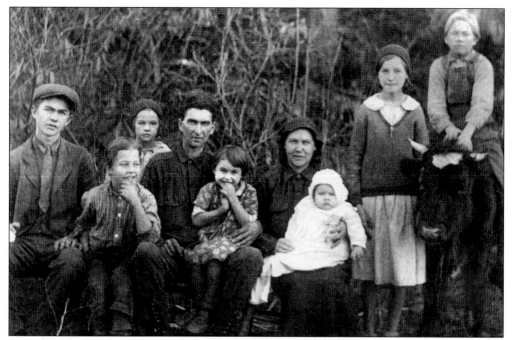

THE WILLIAM ELBERT MCCALL AND SUSIE OWEN FAMILY. Pictured are, from left to right, Emmett, Lloyd, Beulah, Elbert (holding Rosa), Susie (holding Bill), Hassie, and Lawrence on the calf. Most families had many children, who naturally had assigned chores. Children gathered eggs and milked the cow. They also helped churn butter, feed the livestock, and work in the garden. Older girls helped with the cooking and wash, and older boys worked in the fields. (Photo courtesy of Shirley Summey.)

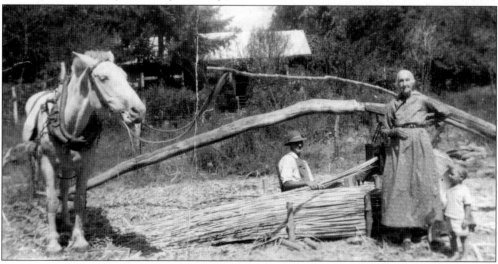

SUGAR CANE. Making molasses was always a good time, even though the work was hard. The juice was extracted from sugar cane by feeding it through a press. It was then transferred to a kettle for cooking. Long-handled paddles were used to skim the top of the boiling juice. The rest was slowly simmered to the right clarity and thickness for molasses. Pictured above, from left to right, are horse "Bob," Elbert Owen, and Charlotte McCall with an unidentified child. (Photo courtesy of Toni McCall.)

WILLIAM WALKER MCCALL AND MARY ANN OWEN. Walker was the son of William M. McCall and Mary Owen. Mary Ann was the daughter of William Owen and Sarah Whitmire. (Photo courtesy of Gwen Ashe.)

ENOS MCCALL AND SARAH JANE WOOD. Enos was the son of Samuel C. McCall and Martha Lanning. Sarah Jane was the daughter of John B. Wood and Rachel Bracken. (Photo courtesy of Jackie Gunter.)

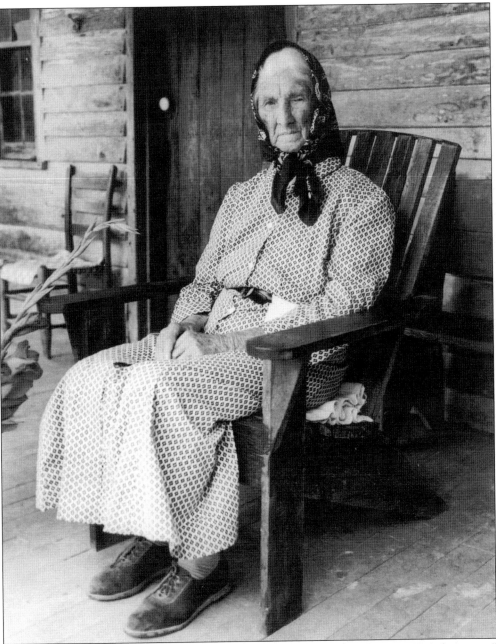

MARY L. MCCALL. Mary was married to Harvey Sylvanis McCall, who was a "tooth jumper," the old-time name for a rural dentist. In her time women relied almost solely on the farm to provide household needs. Down from geese was used to make ticking for mattresses. Those who didn't own geese used straw or cornhusks. It was changed every spring. Every food item was prepared from scratch, including the chicken, which had be killed, scalded, plucked, and then cooked for hours over a fireplace or wood stove. (Photo courtesy of Sadie Price.)

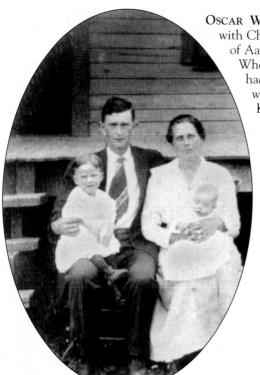

OSCAR WOODARD AND PEARL CASH. Pictured here with Children Lois and Evin, Pearl was the daughter of Aaron Pinkney Cash and Mary Malinda Owen. When she was born in 1890, Idaho and Wyoming had just been admitted into the United States. It was the same year the massacre at Wounded Knee occurred. (Photo courtesy of Kaye McCall Owenby.)

SARAH HASELTINE CATHEY MATHIS. Sarah was the daughter of James N. Cathey and Elizabeth Brown. Women's dresses during the late 19th century had high collars with long sleeves. At age 14, girls started wearing their dresses to the floor. Long hair was braided and balled up on top of the head. Little girls wore long braids and strung pokeberries together for necklaces. (Photo courtesy of Kathy Mason Owens.)

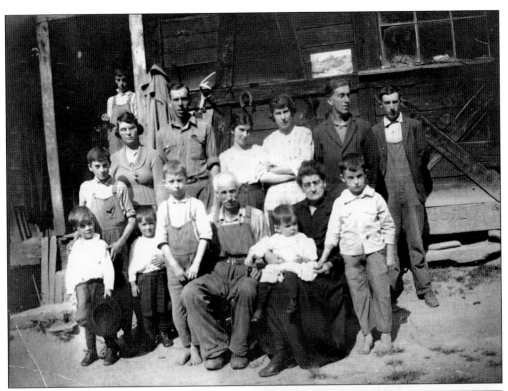

THE WELDON ENGLISH AND ALICE CAGLE FAMILY. Alice Elenora Cagle was born in 1871, a daughter of James Henry Cagle and Rachel Young. She married Weldon English on December 17, 1890, and together they had 11 children. Weldon was born in 1862 and farmed for a living, first in Turkey Pen Gap and later in Boylestown. (Photo courtesy of Sandy Hoxit.)

GEORGE ORR AND MARY JANE PATTON ORR. Mary Jane Patton was born in 1866; according to local lore, she was the first black female to be born free in Transylvania County. She lived to be 104 years old and was the mother of Gertrude Gash—who lived to be 108 years old. Jane married George Orr on December 28, 1879. George was born in 1856 and worked as a carpenter. Jane lost her eyesight a few years before her 40th birthday. This picture of the couple was taken in 1940. (Photo courtesy of Doyce Jeter.)

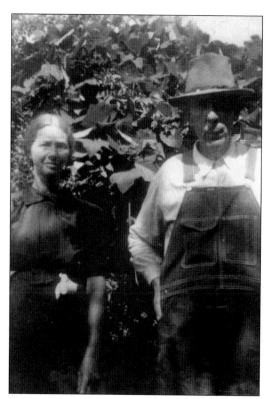

WEB QUEEN AND MARTHA OWEN.
Joseph Wilburn Queen was the son of
Jeptha Queen and Lucinda Bracken.
Martha Queen was the daughter of Isaiah
Owen and Martha Elmina Mason.
Families arose with the break of day, and
farmers were usually in their fields before
the sun was up. They would break at
midday for the noontime meal—the
largest of the day—which was dinner. In
the evening after the chores were done, a
lighter meal was served, called supper.
(Photo courtesy of Rena' Bateman.)

**SAMANTHA McCALL AND DAUGHTER
BESSIE McCALL.** Samantha was the
daughter of James Marion Owen and
Hettie McCall. She married William
Allison McCall. (Photo courtesy of Bessie
McCall Owen.)

JOHN HENRY REID AND SARAH LAVADA BREEDLOVE. Sarah, known as Sallie, was the daughter of Benjamin W. Breedlove and Cynthia Fisher. While her father was in the Civil War, Sallie's mother died at the age of 28, leaving five small children. Her grandfather, John Breedlove, came and took care of them until the war ended. (Photo courtesy of Rena' Bateman.)

CHARLES HEMPHILL AND MARY HUNTER. The Hemphill family knew what it was like to work for a living. Charles not only held a job at the Ecusta plant, he also owned a concrete finishing business. He and his four sons poured driveways and plastered ceilings and walls. Charles also logged and was a farmer. He and Mary raised eight children in the Pisgah Forest area. They are pictured here with grandson Jerome Howell. (Photo courtesy of William Hemphill.)

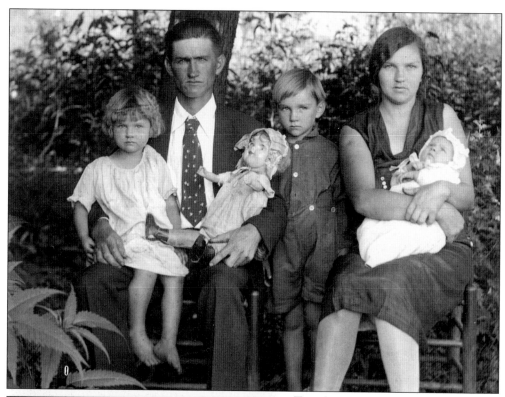

THE CORNELIUS AND VIOLA McCALL FAMILY. Pictured from left to right are Cornelius (holding Louella), Orville, and Viola (holding Evelyn). Cornelius worked later as a deputy sheriff for Transylvania County. (Photo courtesy of Phyllis Cash.)

WILKIE AND PEARLIE McCALL WITH DAUGHTER MAUDIE. Wilkie worked in the logging business and also used his truck to drive all the neighborhood children to school each morning. He placed high sideboards on the bed for their safety. (Photo courtesy of Phyllis Cash.)

Five
CHILDREN AND BABIES

Come all ye fair and tender ladies, take a warning how you court young men
— "Fair and Tender Ladies," Traditional

Children will ever be the hope and glory of mankind. Families have grown smaller through the years, as the farm doesn't need as many hands these days, but the closeness of kin is still just as strong. The children on the following pages were born from the late 1800s to early and mid-1900s. Some are unidentified, not for any ulterior motive but nonetheless protecting the innocent.

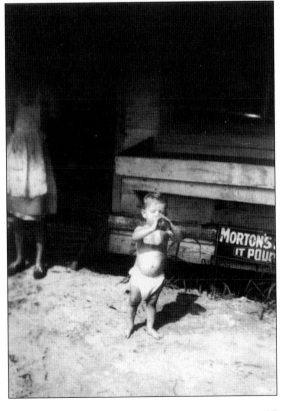

MORTON'S SALT BABY. Children were and are highly valued in mountain families. Most were delivered by a midwife known commonly as a granny women. Her job was not only to provide pre-natal care, but to "catch" the baby at its arrival. To the right of this baby is an old Morton's Salt sign promoting their new product— granulated salt. (Photo courtesy of Linda McCall.)

McCall Children. Pictured from left to right are Donald, Zona holding little brother Dewie, and June McCall, the children of Henson McCall and Enner Brown. Henson owned several businesses in Gloucester during the 1920s: one was a general store, another a barbershop, and another a photography studio. In addition he had a logging crew and was involved in the moving of cemeteries and the demolition of houses to make way for Lake Glenville. (Photo courtesy of Cecil Leslie.)

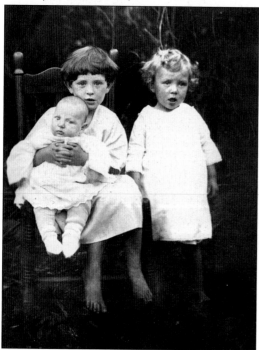

Bumgarner Children. Pictured are Helen holding little brother Hayes, and Dorothy, the children of Radford Bumgarner and Zula Lusk. Radford was a teamster for Carr Lumber, and Zula was the logging camp cook. (Photo courtesy of Ellen Davis.)

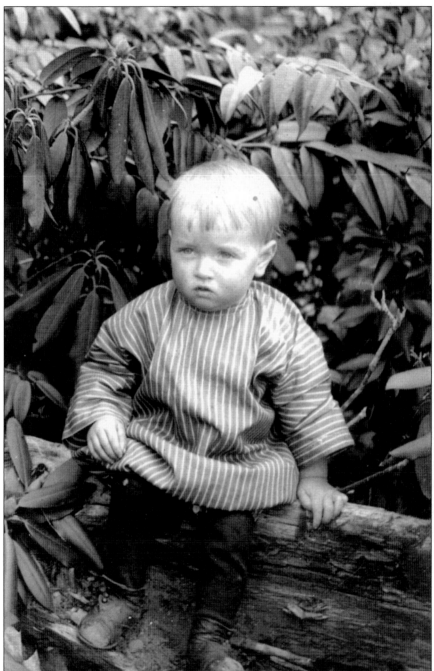

Burles McCall. Children who grew up in the woods learned at an early age how to identify plants—especially poison oak and poison ivy. In the event of a breakout, many mothers used their homemade lye soap to wash the infected area. Jewelweed or "touch-me-not" was often used as a cure. The juice from the crushed stems was rubbed on the rash. Juice from a green tomato and boiled willow leaves were also popular. The mountain laurel behind Burles was often a benchmark for the weather. When the leaves roll up so tightly they are the size of a pencil, it is cold enough to freeze to death. (Photo courtesy of Linda McCall.)

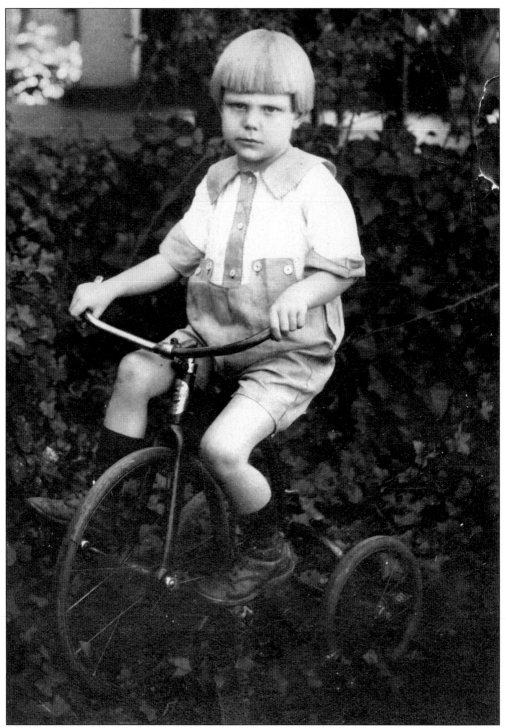

JIMMIE ALDERMAN. Jimmie Alderman was the son of Lucy and R.J. Alderman. Dressed in a typical playsuit of the time, his tricycle of yesterday is much different from those today. (Photo courtesy of Jo Ann Alderman.)

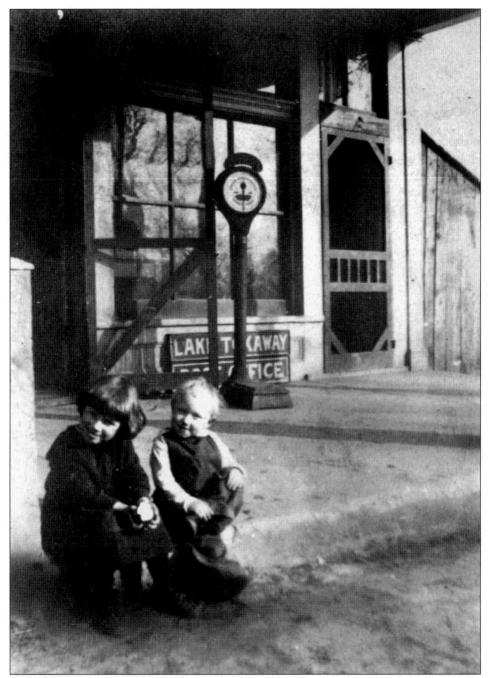

MABEL AND WALTER MCNEELY. These children are caught by the photographer in front of McNeely's Store, which was owned by their parents, Walter and Beulah McNeely. A common item found inside was kerosene, which was used in "doctoring" as often as it was used for fuel. Many families used it as an antiseptic for cuts and puncture wounds to prevent tetanus, known as lockjaw. (Photo courtesy Jo Ann Alderman.)

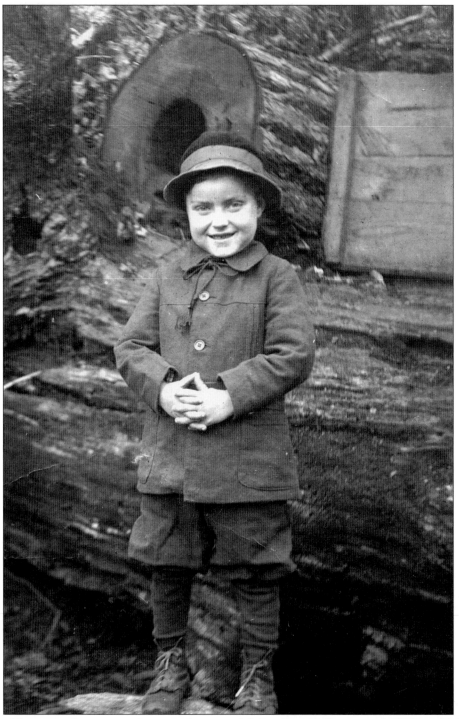

IRA HANFORD ROBINSON. Ira was the son of Julia Ann Galloway and William Nelson Robinson. (Photo courtesy of Phyllis Cash.)

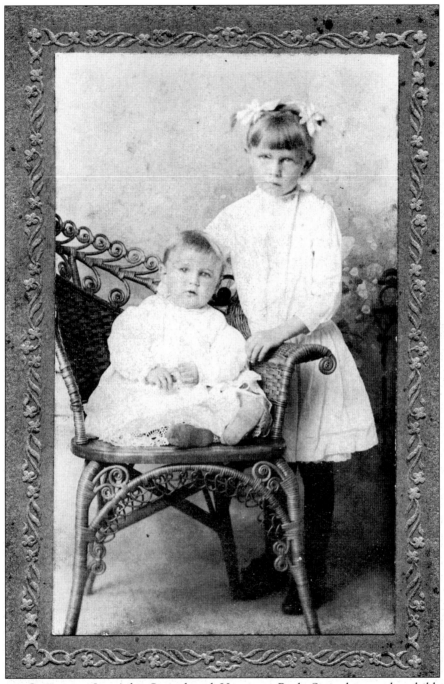

SINIARD CHILDREN. Joe Ashe Siniard and Henrietta Ruth Siniard were the children of Columbus Millard Siniard and Lillie Elvira Mackey. (Photo courtesy of Jo Ann Bryson.)

LITTLE MAN MCCALL. While the exact identity of the child is unknown, he probably belonged to the families of Rufus Elbert McCall and Pernetta Owen or "Singing Lewis" Owen and Violet Jane Wood. "Singing Lewis" was the son of Rev. John Henry "Hatchet Face" Owen. (Photo courtesy of Linda McCall)

HAPPY BABY. This baby belonged to the McNeely/Fisher/Alderman family. While the McNeelys and Fishers resided in Lake Toxaway, the Aldermans lived in Brevard. Isaiah "Slick" Fisher, for whom the road is named, was an ancestor of this child. (Photo courtesy of Jo Ann Alderman.)

Big Shoe Baby. Like the child pictured on the opposite page, this baby also is believed to have been a member of the families of Rufus Elbert McCall and Pernetta Owen or "Singing Lewis" Owen and Violet Jane Wood. (Photo courtesy of Linda McCall.)

CALF ROPE. It was a rite of passage to give a young boy a team of calves to raise. By doing so he became familiar with the handling, training, and working of a team of oxen. As he grew to manhood this skill would pay for itself many times over. (Photo courtesy of Phyllis Cash.)

EUGENE BRACKEN. This little man doesn't lack much of fitting into his jacket. Boys grew up quickly in the mountains and were usually helping with the farm chores at an early age. By the time they reached their teens they were milking, plowing, hoeing, and tending to the stock. (Photo courtesy of Phyllis Cash.)

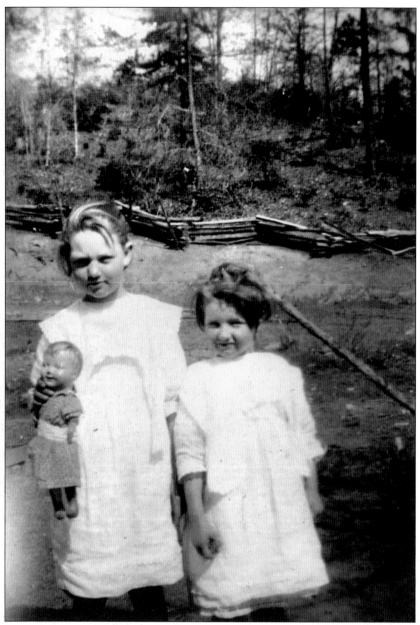

MAUDIE AND KATIE MCCALL. Maudie Elmina and Emily Katie Ann were the daughters of Wilkie and Pearlie McCall. Since there were only the two of them, they would jump rope by typing one end of the rope to the porch and let one turn while the other jumped. (Photo courtesy of Phyllis Cash.)

KITTEN GIRL. Little girls and kittens just seem to go hand-in-hand. Almost all children had a favorite pet or two among the farm animals. (Photo courtesy of Linda McCall.)

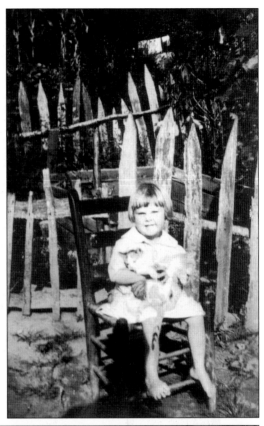

GALLOWAY GIRLS. Pictured from left to right are Ruby, Ruthie, Bessie, and either Pauline or Edith Galloway. (Photo courtesy of Linda McCall.)

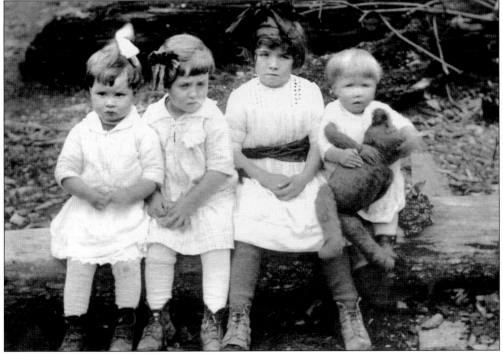

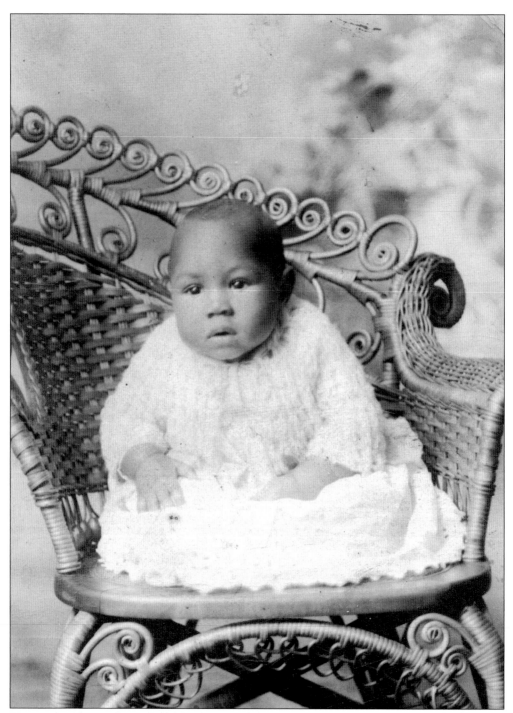

UERAL GASH. Ueral was the eldest son of Moses Gash and Gertrude Orr Gash. Baby gowns such as pictured were reserved for special occasions, such as a baptism or christening. Most were handmade with hours of work spent on lace and embroidery. White is such a traditional color that it's hard to imagine prior to the 18th century such gowns were brightly dyed. The French introduced the elaborate white gown around 1700. (Photo courtesy of Doyce Jeter.)

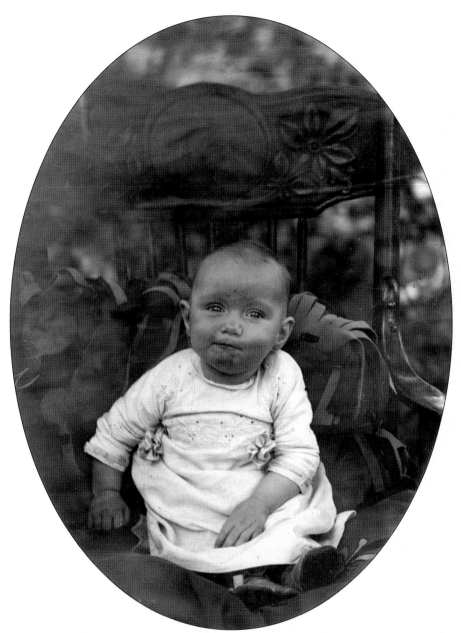

THAT'S A GOOD CHEW, GRANNY! Teething and toothaches were always a challenge for any new mother trying to comfort her child. Sometimes a small root of a peony plant was tied around a baby's neck as a teething ring. An old remedy for toothaches was crushed Broad-leaf plantain placed into the cavity. Some mothers used wood ashes wrapped in a clean cloth to ease the pain. Others used a drop of vanilla extract, burned alum, or cloves. Crushed garlic was used by placing it on the opposite wrist of the toothache. (Photo courtesy of Jo Ann Alderman.)

OWEN CHILDREN. Pictured from left to right are Berlin, Aileen, and Othaleen Owen. (Photo courtesy of Linda McCall.)

MAX AND MYRTLE WILSON. Pictured here are the children of Charlie Waitsell Wilson and Bertha Fanitta Collis. (Photo courtesy of Stephen Lee Sitton.)

WILEY AND LOONIE OWEN. Pictured here are the two youngest sons of Tillman Owen and Sallie Parker. Wiley William was born in 1894, and Loonie Dillard "Lun" was born in 1897. They were the grandsons of John Bishop "Dick" Owen III and Malinda Reid. (Photo courtesy of Phyllis Cash.)

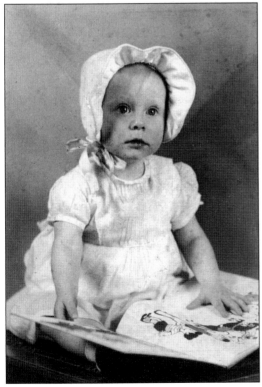

JO ANN ALDERMAN: Jo Ann, a well-known artist of Transylvania County, is the daughter of Jimmie Alderman and Maybel McNeely. (Photo courtesy of Jo Ann Alderman.)

HELEN ENGLISH. Family legend tells of Helen's love of eggs and the raids she made on the hen's nests. Helen was born in Avery's Creek and raised in logging camps. She married Tom English. (Photo courtesy of Ellen Davis.)

Six

MAKING A LIVIN'

Well I've eat more chicken than a pretty gal can fry, I'll tell you no doggone lie.
—"Raleigh and Spencer," Traditional

When the Depression hit in 1929, Transylvania suffered along with the rest of the nation. Those who still farmed were better off than the ones who relied on jobs for income and groceries. Business was at a standstill, and many companies either closed their doors temporarily or shut down for good.

The Roosevelt Administration put into place work programs which not only gave men jobs, but also improved the community's assets. At the outbreak of World War II, the economy improved, and by the end of the war, an idyllic lifestyle had become a reality. Transylvania County had some golden years coming.

DEPRESSION DOG. During the Depression, business was slow and the days lazy. There was nothing to do and nowhere to go. (Photo courtesy of Jo Ann Alderman.)

LAST LOAD OUT. As the logging industry began to die out and the Depression closed in, men returned to small farming to support their families. After World War I, there were signs that a Great Depression was coming. A red flag was the lack of increase in the workingman's pay. With no disposable income, folks could not afford manufactured goods. Commercial farmers also made very little profit, resulting in the inability to purchase new machinery, which slowed down production. (Photo courtesy of the Historic Preservation Commission.)

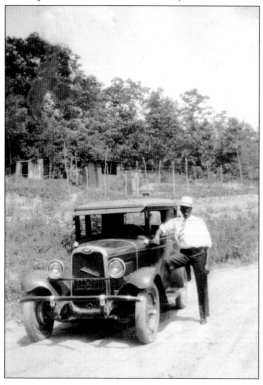

MOSES GASH. Moses is pictured standing beside the first car he ever owned. Before the stock market crashed, a new economic plan was created, called the installment plan. This arrangement allowed Americans to buy goods on credit. Depending on family income, the plan worked well for some families but poorly for others, who soon found themselves in debt. (Photo courtesy of Doyce Jeter.)

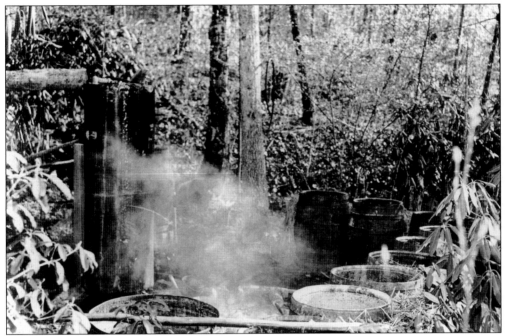

MOONSHINE. Colonists brought with them many skills including whiskey making. When the men of the mountains found no market for their excess corn, they often turned to the whiskey trade, as it was an easily transported product and could be sold for cash. The three main ingredients for making shine are corn, water, and solitude. (Photo courtesy of the Historic Preservation Commission.)

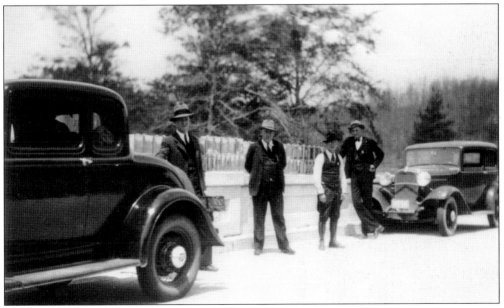

SHINE POUR. The moonshine trade experienced a boon during Prohibition and the Great Depression. Many citizens felt the same as Zeb Vance when he protested revenue laws in 1876, saying, "The time has come when an honest man can't take an honest drink without having a gang of revenue officers after him." (Photo courtesy of the Historic Preservation Commission.)

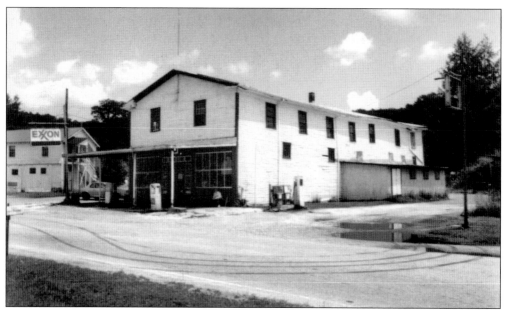

THE OLD COMPANY STORE. The Gloucester Lumber Company store was located next to the garage, and was also built in 1910. Rosman was a booming town with loggers, contractors, and 300 mill workers living among the existing residents. The company store was a focal point of the neighborhood, and was often so crowded it was hard to find standing room. (Photo courtesy of Elvin Holden.)

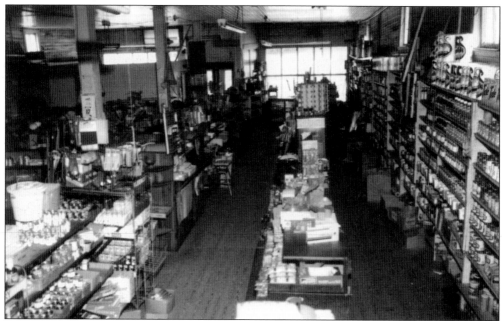

INSIDE THE OLD STORE. As the logging trains rolled through unloading their timber, they stopped at the company store and restocked supplies to deliver back to the logging camps. Some nights, the store would stay open as late as 1:00 a.m. and be packed with business. Even after the logging industry left Rosman, the store remained open and was a tourist attraction for years. (Photo courtesy of Elvin Holden.)

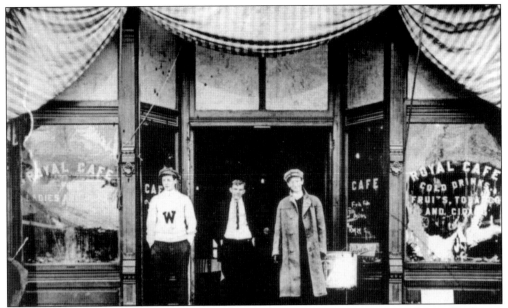

ROYAL CAFE. In the 1880s, the Temperance Movement tried to revive the coffee house scene in an attempt to divert the workingman from the perils of drink. Called cafés, they have been reinvented many times over the centuries. In America it came to mean an eatery. The Royal Café advertised itself for ladies and gents and offered among the menu fresh fish and oysters, cold drinks, fruits, tobacco, and cigars. (Photo courtesy of the Historic Preservation Commission.)

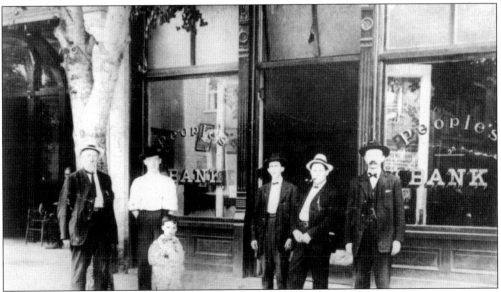

PEOPLES BANK. The Great Depression was widely blamed on stock market speculation, reckless banking practices, and a concentration of wealth in too few hands. Recent economic research suggests the best way to promote a speedy recovery from any depression is to let people keep more of their money, remove obstacles to productive enterprise, let markets rather than regulators make decisions, and provide stable money and a political climate where investors feel that it is safe to invest for the future. (Photo courtesy of the Historic Preservation Commission.)

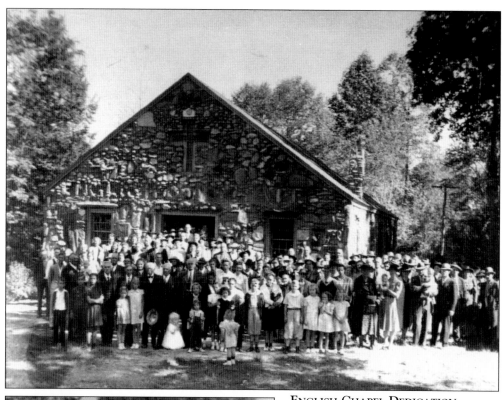

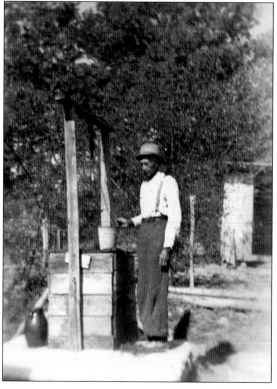

ENGLISH CHAPEL DEDICATION. This picture was taken during the dedication of the new chapel in October of 1940. The stone for the chapel came mostly from the Davidson River. The original church was established in 1860 and was made of sawed lumber from Methodist circuit rider Rev. A.F. English's mill. The land was donated by his father-in-law, Strawbridge Young, for the price of $5. Also known as Young's Chapel and Union Chapel, English Chapel has maintained its autonomy throughout its history. (Photo courtesy of Mary Galyon.)

GEORGE ORR. Pictured on October 9, 1940, George Orr is shown drawing water from his well. Even if there was a creek beside the home, a well was often dug to insure the family had safe water to use. The earth between the well and the water source was used as a filter. Old wells often doubled as refrigerators for milk, cream, and butter. (Photo courtesy of Doyce Jeter.)

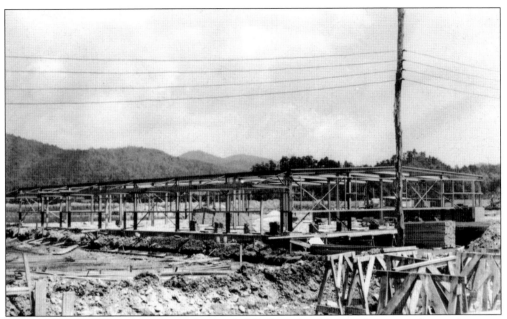

ECUSTA CONSTRUCTION. Harry H. Strauss boldly brought the manufacturing of cigarette paper and bible pages to Transylvania County when he built his paper mill on the Davidson River. Fiske-Carter of Greenville, South Carolina, and the engineering firm of J.E. Dirriane handled the $2 million construction. The new industry was largest employer in the county for many years, with Dupont Imaging and America Thread following close behind. (Photo courtesy of the Historic Preservation Commission.)

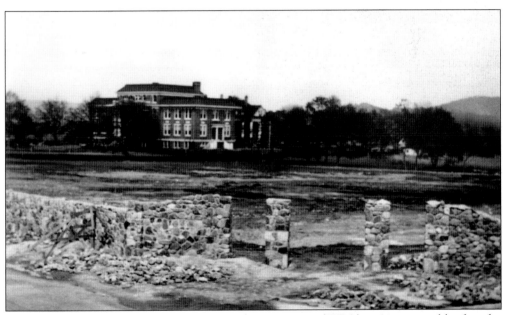

COLLEGE WALL. The Works Progress Administration (WPA) was responsible for the construction of this wall, which utilized the labors of local stonemasons and college students alike. The stones were harvested from Davidson River. (Photo courtesy of the Historic Preservation Commission.)

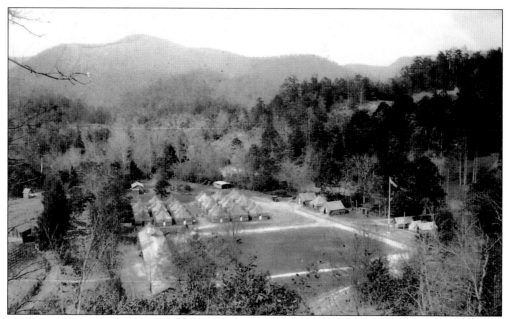

CIVILIAN CONSERVATION CORP. From 1933 to 1942, the CCC helped stabilize the economy by employing young men to build roads, trails, parks, and other much needed environmental projects. Many of these young men would meet their future brides in the surrounding communities. This camp, F-14, was located in Balsam Grove. Another camp was located at John's Rock. (Photo courtesy of Rena Bateman.)

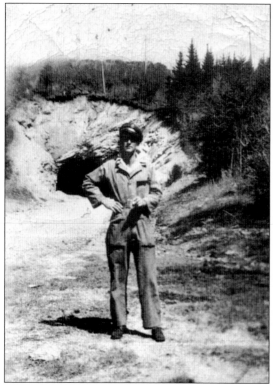

DEVIL'S COURTHOUSE TUNNEL. World War II interrupted the work on the Blue Ridge Parkway. After Pearl Harbor, the men of the CCC went to war or to better paying jobs. By 1942, funding for the CCC was discontinued. Work on the parkway resumed after the war, and was completed by the end of the decade. In this picture, Donald McCall of Balsam Grove, who served with the RTC 32 Company, stands before the incomplete Devil's Courthouse tunnel. (Photo courtesy of Linda McCall.)

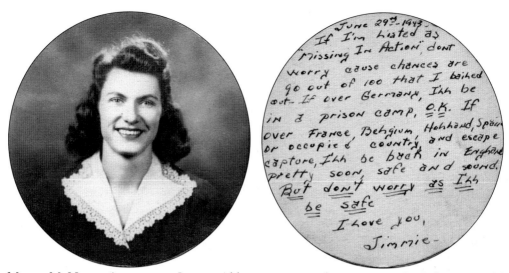

June 29th 1943
If I'm listed as "missing in action" don't worry cause chances are 90 out of 100 that I bailed out. If over Germany, I'll be in a prison camp, O.K. If over France, Belgium, Holland, Spain or occupied country, and escape capture, I'll be back in England pretty soon, safe and sound. But don't worry as I'll be safe
I love you,
Jimmie-

MABEL McNEELY ALDERMAN. Jimmie Alderman was a tail gunner on a B-17 during World War II. He took a small black case holding a picture of his wife Mabel with him to England. Jimmie's plane was shot down over Germany in August 1943 and he was listed as MIA. The Army sent his effects home, and Mabel Alderman took the small black case and disassembled it; written on the back of her image was a note from Jimmie.

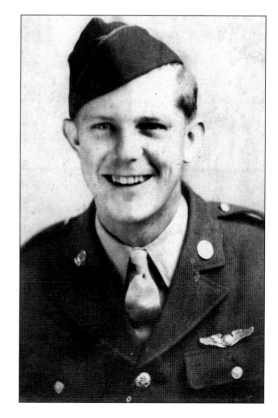

JIMMIE ALDERMAN. Jimmie had bailed out of the plane before it crashed. He spent 22 months in Stalag 17 before his release, when Patton stormed Germany from North Africa. Jimmie was sent home in the summer of 1945. During his absence he was decorated with a Purple Heart, one of two he received in his career. (Photos courtesy of JoAnn Alderman.)

ARMY HOUSING. One source of affordable housing was utilized by "Big Bill" McNeely, who made a trip to Virginia after World War II and purchased the structures once used as army barracks. He hauled them back to Brevard on flatbed trucks and set them up in the area of College Heights. Some of these houses still remain. (Photo courtesy of Jo Ann Alderman.)

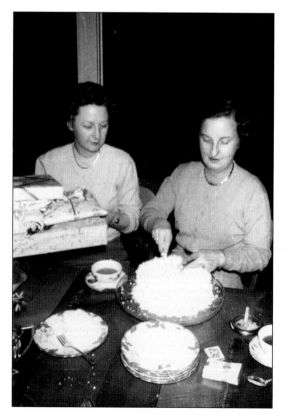

GINGER AND DILLY WARD. This picture was taken on the birthday of the Ward sisters, who owned and operated Ward's Newsstand in Brevard. Ward's was located on West Main Street, next door to what in 2004 is O.P. Taylors. An icon of the community, Ward's sold newspapers and magazines as well as comic books, candy, and sodas. During the days of Ward's, O.P. Taylors was Morris Pharmacy. On the other side was Patterson's clothing store. (Photo courtesy of Jo Ann Alderman.)

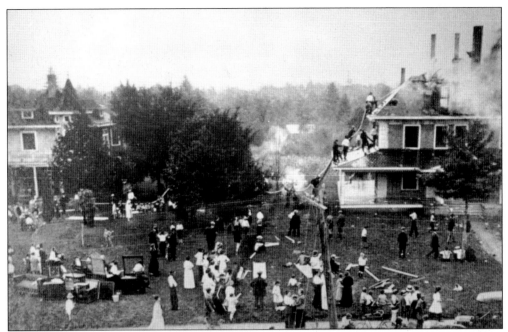

MOFFIT HOUSE. This house, on Country Club Road, was built in 1911 by Everett Moffit. When it caught fire in 1914, the local fire department responded quickly and climbed three stories to save the building. The neighborhood gathered together and watched the exciting event unfold. Note the stack of furniture on the left that had been rescued from the dwelling. (Photo courtesy of the Historic Preservation Commission.)

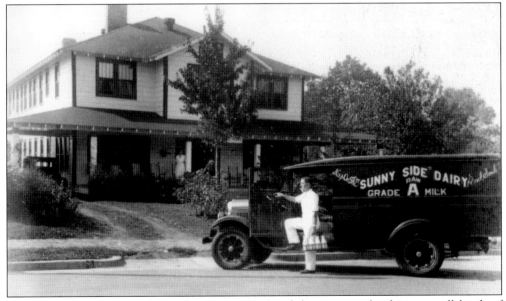

PIERCE MOORE HOTEL. The milkman was a part of the morning landscape in all kinds of weather. The short shelf life of unprocessed milk made daily delivery and consumption an imperative. At first, milk was delivered by wagon, and milk and cream were ladled right into the customer's own container. By the 1950s, large companies maintained a fleet of route trucks to deliver to individual households. (Photo courtesy of the Historic Preservation Commission.)

APPLE GROVE BOARDING HOUSE. Located where Eldridge Motors stands today, this house was built by Lambert C. Neill and was used in the Civil War as a departure point for soldiers. Mary Neill married Robert Maxwell. John Maxwell and his wife Mary Kate Gash ran the boarding house. They rented their barn to Mr. Alexander, from Camp Carolina, who stabled the camp horses there. (Photo courtesy of Jo Ann Bryson.)

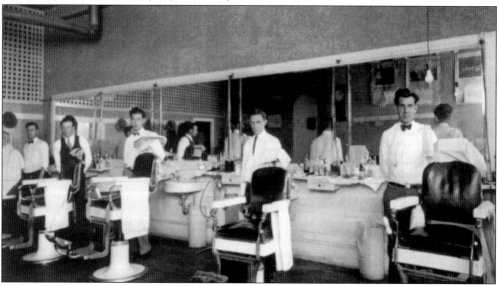

SIMPSONS BARBER SHOP. Barbershops were considered a social institution in any small town. Some patrons went daily for a shave, while others dropped in once or twice a month to get a haircut and talk about the weather, crops, and town politics. (Photo courtesy of the Historic Preservation Commission.)

JOE'S LITTLE STORE. Owned by Joe Siniard, Joe's Little Store was another place to hear all the local news. Between the potbellied stove inside and the benches outside, Joe's was a true "loafer's glory." A group of men could be found there almost any time laughing and swapping lies. The land is part of a 200-acre tract originally owned by Gaston Siniard. (Photo courtesy of Jo Ann Bryson.)

INSIDE JOE'S LITTLE STORE. Joe carried mostly hunting and fishing supplies—including live bait—but just about anything else you needed could be found there: light bulbs, thread, snuff, pocket knives, cigars, and even a few things for the ladies packed every inch of the establishment. (Photo courtesy of Jo Ann Bryson.)

PAUL'S PRODUCE. Paul Patterson kept such delectables as tomatoes, corn, potatoes, peaches, and apples in the large bins out front. Inside, he carried canned groceries and fresh bread. Built in 1925, it was the only wooden commercial building in downtown Brevard. Before Paul took it over it was Harris Service Station. The building has undergone various changes in owners since Paul, and is currently the home of El Ranchero, a Mexican restaurant. (Photo courtesy of the Historic Preservation Commission.)

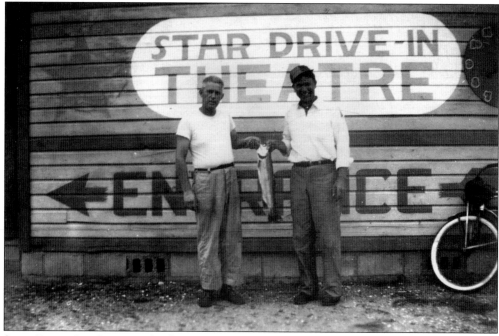

STAR DRIVE-IN. Going to the drive-in was a favorite pastime for families, who would load up the kids in the car and go see a show. Teenagers often spent Friday night—"date night"—the same way. Here, Joe Siniard and Walter "Bud" Siniard show off their catch of the day in front of the marquee. (Photo courtesy of Jo Ann Bryson.)

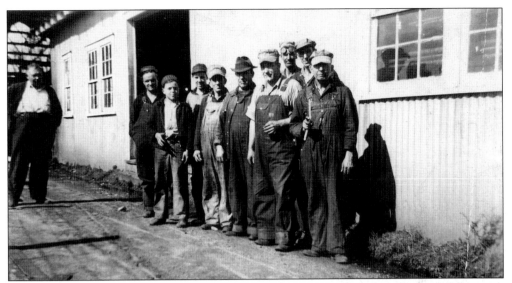

SID BARNETT'S MACHINE SHOP. Sid Barnett's shop was a fast, friendly, and full-service machine shop where materials, especially metals, were cut and formed for specific engineering requirements. Sid handled projects, repairs, modifications, prototypes, and small-quantity production. (Photo courtesy of Sandy Hoxit.)

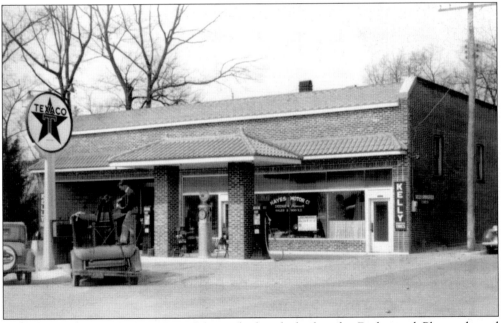

HAYES MOTOR COMPANY. Hayes Motors had a dealership for Dodge and Plymouth and offered sales and service on new and used cars. They ran a garage, a wrecker service, and a gas station. In those days, gas was cheap, and you could get your windshield washed, your oil checked, and air in your tires while the pump was running. (Photo courtesy of the Historic Preservation Commission.)

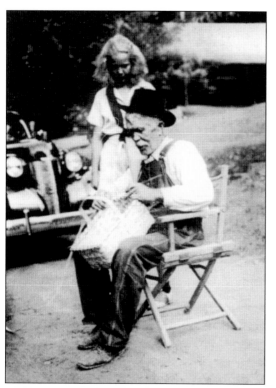

WILLIAM HARRISON HOGSED. The old ways still lingered among most families, who usually had an elder ready to pass on their knowledge. Here William Harrison Hogsed teaches the children at Rock Brook Camp how to make baskets. Rock Brook is located on Greenville Highway. (Photo courtesy of Jean and Leon Pace.)

END OF AN ERA. The second half of the 20th century would see Transylvania County go through a multitude of changes. More wars were on the horizon along with political, social, and economic change. The quiet life of the small community would be challenged, but would weather the coming storms. (Photo courtesy of the Historic Preservation Commission.)

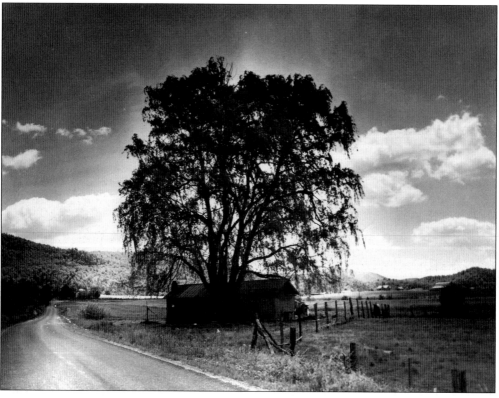

Seven

THE WINDS OF CHANGE

Just remember the Red River Valley, and the poor girl who loved you so true.
—"Red River Valley," Traditional

As Transylvania County moves into the 21st century, new challenges have arisen with the collapse of local industry. When plants such as Ecusta, Dupont, and American Thread closed their doors, the citizens of the county had to rethink their means of making a living. Tourism still flourishes during the warm months, and the quiet winter supplies long evenings for arts and handicrafts. Like their ancestors before them, the folks of Transylvania are resourceful, intelligent, and talented. The coming years will only show that surviving is always the thing they do best.

COURTHOUSE WALL. A favorite gathering place of old and young alike was the Courthouse wall. During the day, gentlemen sat and passed the time with each other, while in the evening, a younger crowd met and socialized. (Photo courtesy of the Historic Preservation Commission)

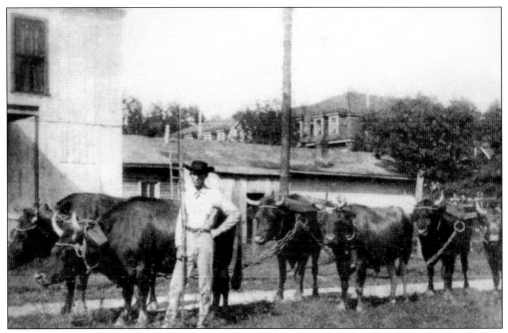

Lumber Team. Pictured are an oxen team and driver hauling lumber down Jordan Street. They are standing near the modern-day parking lot, up the street from the alley. The top of the Aethelwald Hotel can be seen in the background. (Photo courtesy of the Historic Preservation Commission.)

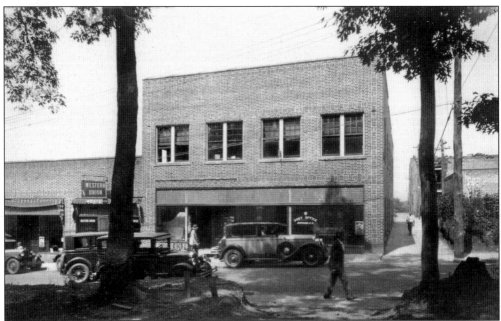

Jordan Street. This view of Jordan Street shows where the post office and Western Union once were. The end office belonged to Frank Beasley. Jordan Street was named for Joseph P. Jordan who first introduced to the North Carolina General Assembly an act to establish a new county named Transylvania. (Photo courtesy of the Historic Preservation Commission)

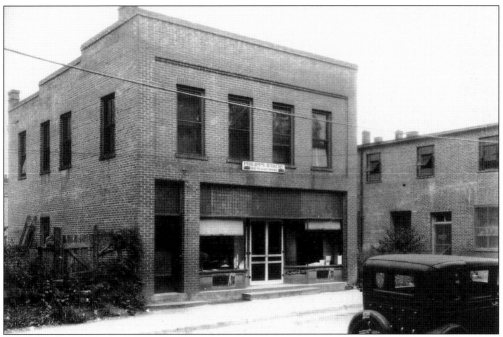

PHILLIPS BAKERY. Phillips Bakery was located on East Main Street and sold fresh bread, pies, cakes, and soft drinks. (Photo courtesy of the Historic Preservation Commission.)

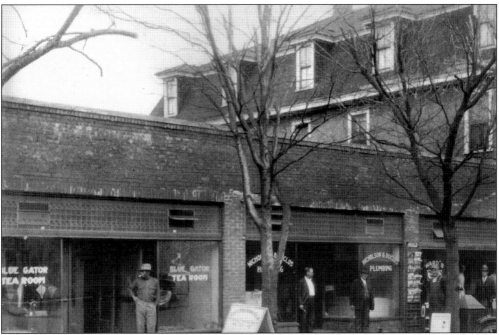

BLUE GATOR TEA ROOM. During one phase of Brevard, the Blue Gator Tearoom stood at the end of West Main Street. Nicholson and Duclos Heating and Plumbing stood next door, and next to them was the old Ward's Newsstand. The top of the Clayton Hotel can be seen in the background, which stood on the corner of West Main and Caldwell. (Photo courtesy of the Historic Preservation Commission.)

TOWN SQUARE VIEW ONE. This picture of West Main Street was taken in the late 1890s. The building right behind the gentlemen is the McMinn House, a former hotel and store located behind the current McMinn Building. The house stood where Plummers store was located in 1965. In 2004, it is the home of Ragland Electric. (Photo courtesy of the Historic Preservation Commission.)

TOWN SQUARE VIEW TWO. The same view is seen around 1902, with the Z.W. Nichols drug store occupying the McMinn Building. Note the introduction of power lines and streetlamps. Bundles of pipe line the left side of the road, while a carriage, cart, and wagon are parked on the right. The D.L. England dry goods and clothing store is on the corner at left. (Photo courtesy of the Historic Preservation Commission.)

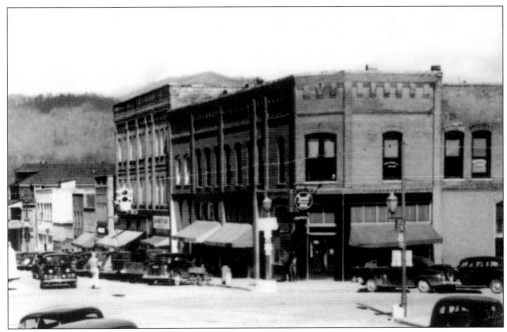

TOWN SQUARE VIEW THREE. This view was taken sometime in the 1940s and shows Macfie's Drug Store in the McMinn Building. Note the introduction of awnings, sidewalks, paved roads, cars, and traffic lights, as well as the removal of trees. (Photo courtesy of the Historic Preservation Commission.)

TOWN SQUARE VIEW FOUR. This view was taken in 2004. The White Squirrel now occupies the McMinn Building. Note the introduction of highway signs, the taller streetlights, and change of direction in parking, not to mention the reintroduction of trees! (Photo courtesy of Sean Trapp.)

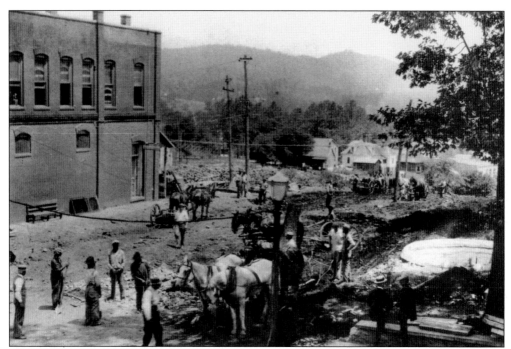

THE PAVING OF JAILHOUSE HILL. The paving of Jailhouse Hill was a milestone of progress for the town of Brevard. The steep grade made the going rough during wet weather. In winter, the constant freezing and thawing of the dirt road created a quagmire of mud that was best avoided. (Photo courtesy of the Historic Preservation Commission.)

DOWNTOWN BREVARD. Taken from the top of the old Aethelwald Hotel, this view shows Jailhouse Hill as it is today. The grade is still as steep, but the traveling is much easier. This photograph was taken during the fall of 2004. (Photo courtesy of Sean Trapp.)

THE OLD BOYLSTON ROAD. Once known as the Boylston Road, this main thoroughfare was muddy and treacherous to travel. Pictured above is a view going toward Brevard from Pisgah Forest. Lamb's Creek Road is on the right. Morris Road is around the curve on the left. (Photo courtesy of Mary Galyon.)

THE FOUR-LANE. Now known as Highway 280, the view is once again going toward Brevard from Pisgah Forest. Lamb's Creek Road is on the right. Morris Road is around the curve on the left. This photograph was taken during the fall of 2004. (Photo courtesy of Sean Trapp.)

THE AUTHOR. Pictured are Yvonne McCall with her father, Jack H. McCall, and the family coon dogs. Jack was the son of Miles Henson McCall and Enner Brown. He liked to coon hunt and always kept a pack of dogs, most of them Treeing Walkers or Blueticks. (Photo courtesy of Mamie McCall.)